Contents

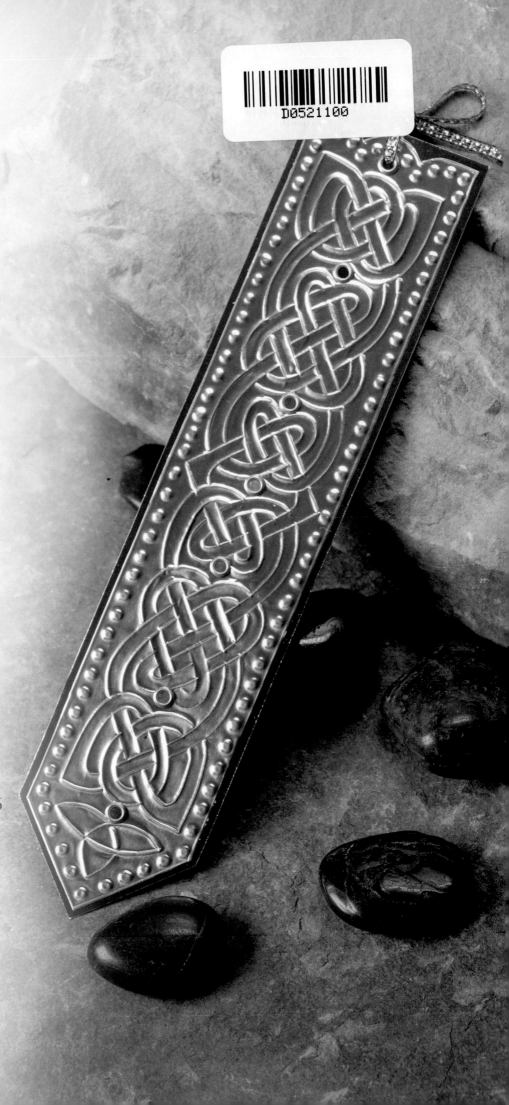

Introduction

The origins of the Celts can be traced back over nearly three thousand years and we are fortunate to have been left a rich legacy of decorative imagery that continues to inspire artists and craftspeople today. There are no written records of Celtic life because the knowledge and wisdom of these brave warriors and tribes were passed down orally by storytellers and bards. Their culture is reflected in ancient tales, myths and legends and in the wonderful archeological finds that have been discovered over the centuries.

There are over two hundred and fifty illustrations in this book including interlacing patterns, spirals, intricate knotwork, figures, symbolic animals and more, all inspired by early Celtic designs. Simple and more elaborate, these images are instantly recognisable with their twists, curves and fluid unbroken lines. Here you will discover simple and ornate borders, stylised motifs and beautiful decorative panels. You do not need artistic skills, just photocopy or trace the motifs, pictures and patterns, then transfer them on to your project pieces. You will soon discover how easy it is to make unique designs for yourself, or friends and family.

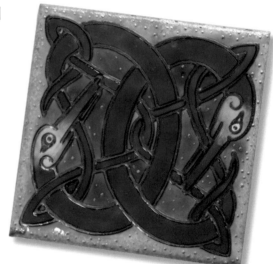

The first section of the book offers some different ideas and includes an embroidered book cover by Jenny Rolfe and a selection of craft projects by designer Judy Balchin. Their chosen illustrations have been transferred on to different surfaces and used to decorate cards, boxes, panels, a bookmark and a cushion. The techniques vary from simple colouring and layering to glass painting, ceramic painting and metal embossing. Full instructions are not given for any of these items; they have been included to inspire you and to show what can be achieved. However, if you do feel tempted to create any of them, we offer a full range of technique books on our website: www.searchpress.com.

As your confidence and skills grow, you will soon discover how enjoyable it is to develop the designs in your own way using your favourite techniques. Have fun.

The Search Press Team

Dragon Plaque
Design, see page 72
Knotwork Clip Frame
Design, see page 42

By Judy Balchin

The rich, vibrant colours and strong black outlines found in Celtic designs are ideal for ceramic and glass painted projects, as illustrated on these pages. Celtic knots can be intricate and do demand good control of the outline. Persevere... the results are well worth it!

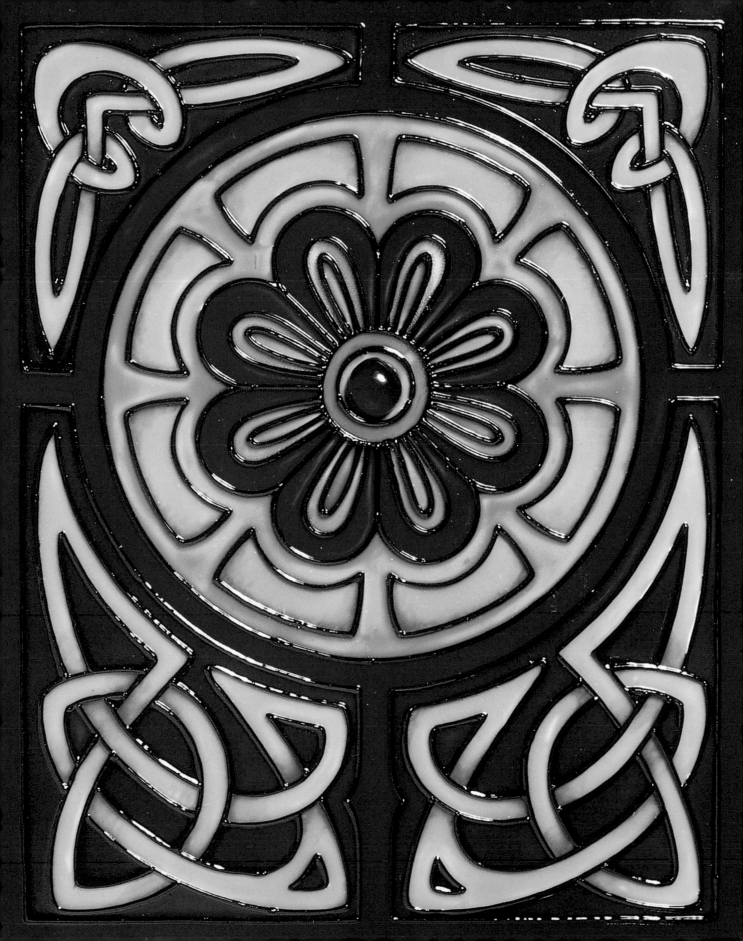

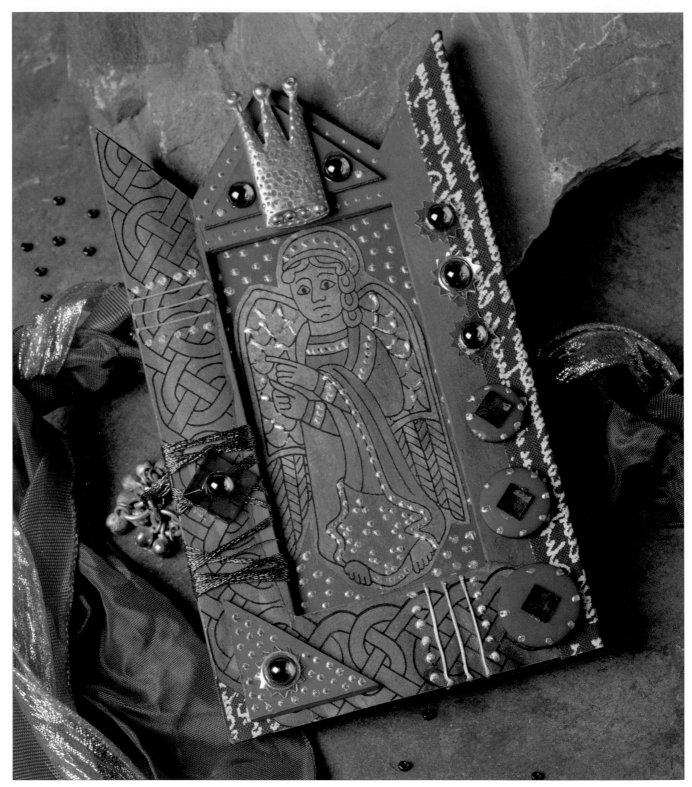

Vibrant Angel Picture

By Judy Balchin

Design, see page 73

This colourful picture started with just a few bits of card and some photocopies of the designs. Two pieces of thick card are used for the frame and backing. These are painted roughly with vibrant colours. The knotwork border is painted, cut out and used to decorate the frame. The Angel design is reversed, cut out and used as the central image. Sequins, assorted gems, small bells, buttons, glittering threads, lettered tape and a crown embellishment are glued on to the border to complete the picture.

Opposite:

Christmas Cards

By Judy Balchin

Designs, see page 38 (top) and 73 (bottom)

Celtic designs are perfect for metal embossed projects. A medieval paper border is used to complement the gold bell design. A more subtle background paper panel is used behind the silver Angel. Both cards are embellished with brads and eyelets are punched into the Angel's paper background.

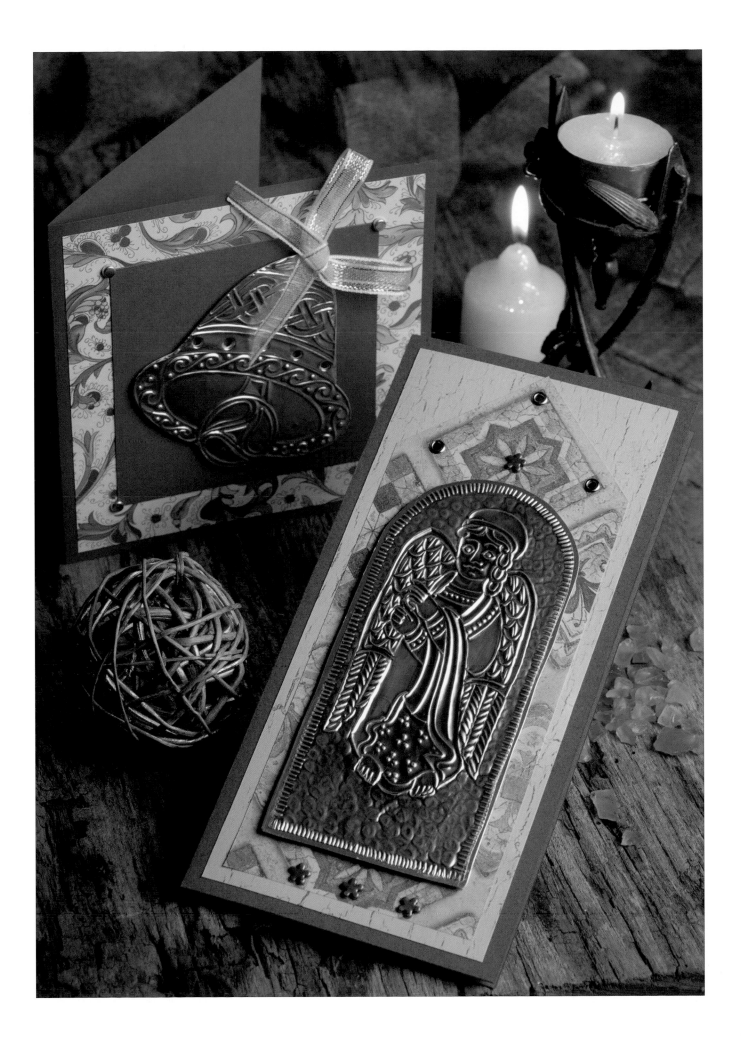

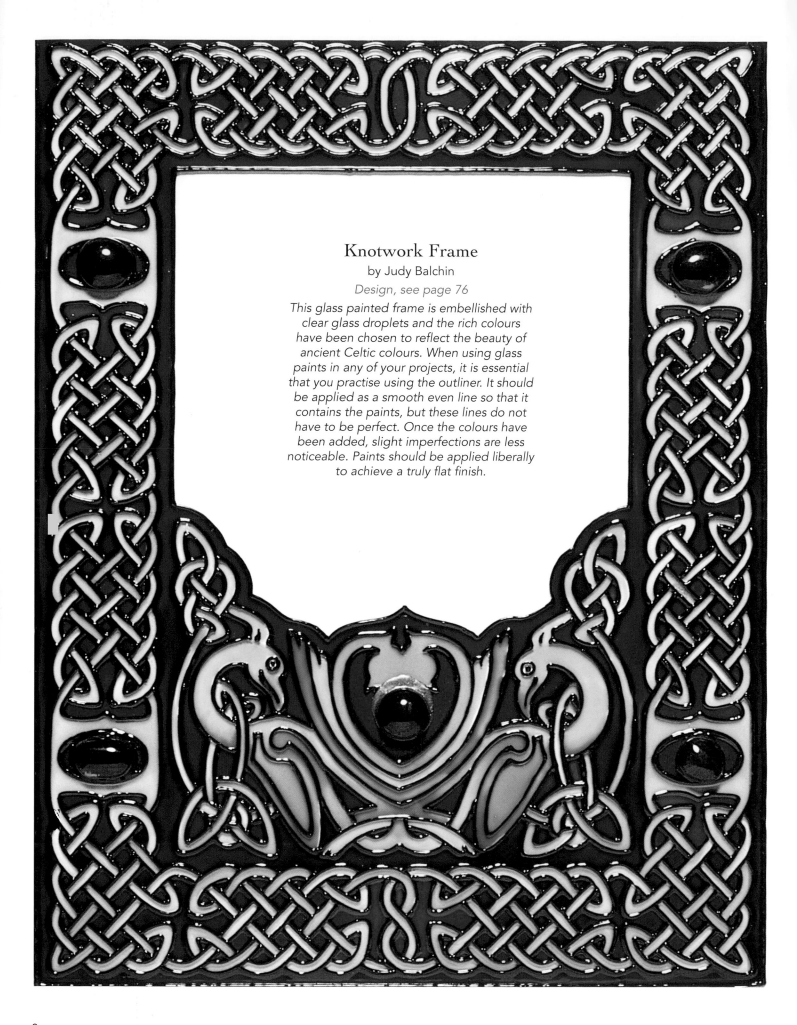

Knotwork Frame

by Judy Balchin

Design, see page 76

This glass painted frame is embellished with clear glass droplets and the rich colours have been chosen to reflect the beauty of ancient Celtic colours. When using glass paints in any of your projects, it is essential that you practise using the outliner. It should be applied as a smooth even line so that it contains the paints, but these lines do not have to be perfect. Once the colours have been added, slight imperfections are less noticeable. Paints should be applied liberally to achieve a truly flat finish.

Monogrammed Mug

By Judy Balchin

Designs, see pages 53 and 93

The alphabet designs in this book are perfect if you want to personalise a gift. Here, the letter W and a knotwork border are used to tranform a plain white ceramic mug. The designs are transferred on to the surface using carbon paper, outlined, then painted with ceramic paints. The mug is baked in a domestic oven to make it durable.

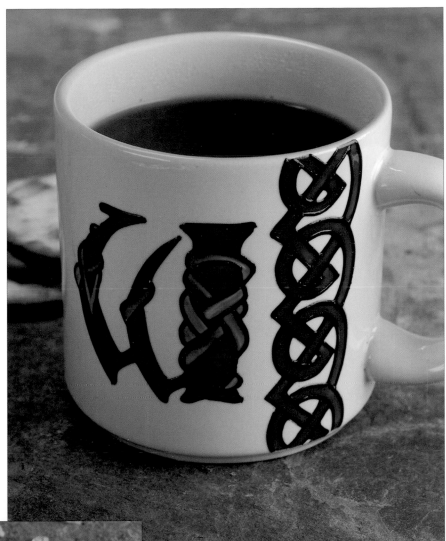

Dragon Plaque

By Judy Balchin

Design, see page 72

Intertwining dragons decorate this ceramic tile. The design is outlined with black outliner, then filled in with bold colours to give a strong, dramatic look. The edge of the tile is decorated with dots of gold paint.

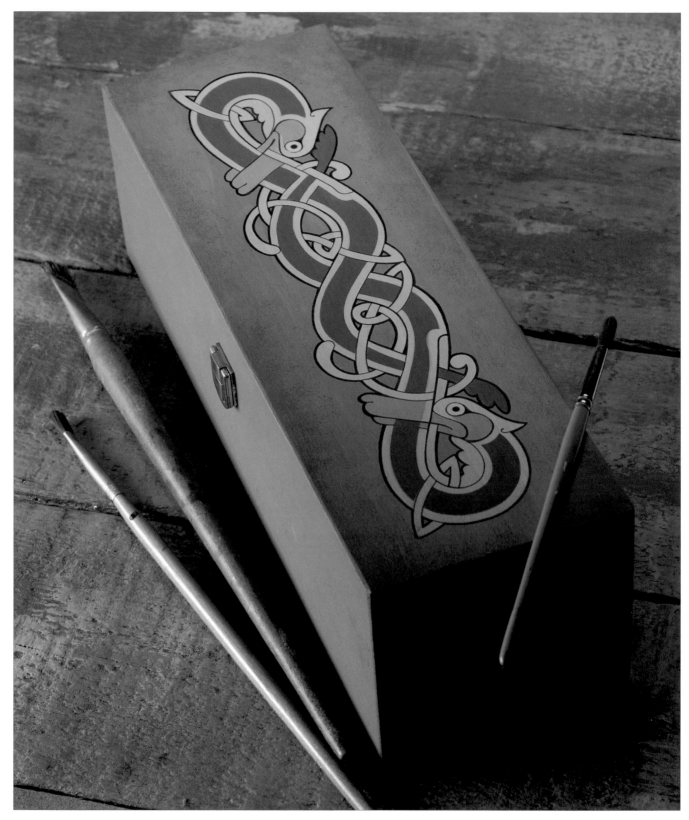

Pencil Box

By Judy Balchin

Design, see page 81

This wooden pencil box is sponged with natural earthy colours to give it a textured, aged feel. When dry, the intertwining zoomorphic design is transferred on to the lid using transfer paper, then painted with muted colours to enhance the natural theme. Finally, the design is edged with a permanent felt tip pen to give it definition.

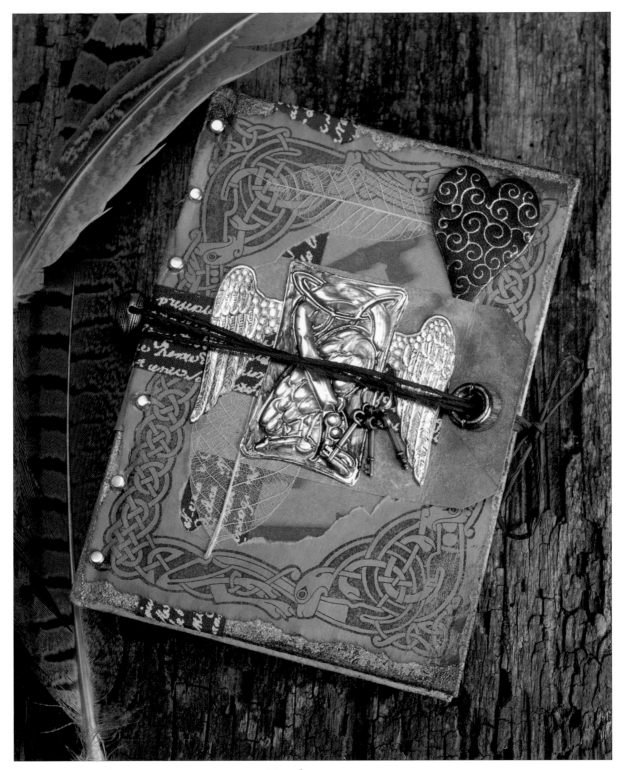

Book cover

By Judy Balchin

Design, see pages 44 and 83

The designs are photocopied and aged with coffee. They are then torn and glued on to the cover along with old labels, lettered tape, skeleton leaves and a fabric heart, to create an ancient, intricate look. The central gold metal embossed design is flanked by two gold paper wings. The book is then bound with cord and studded with small gold embellishments down the spine.

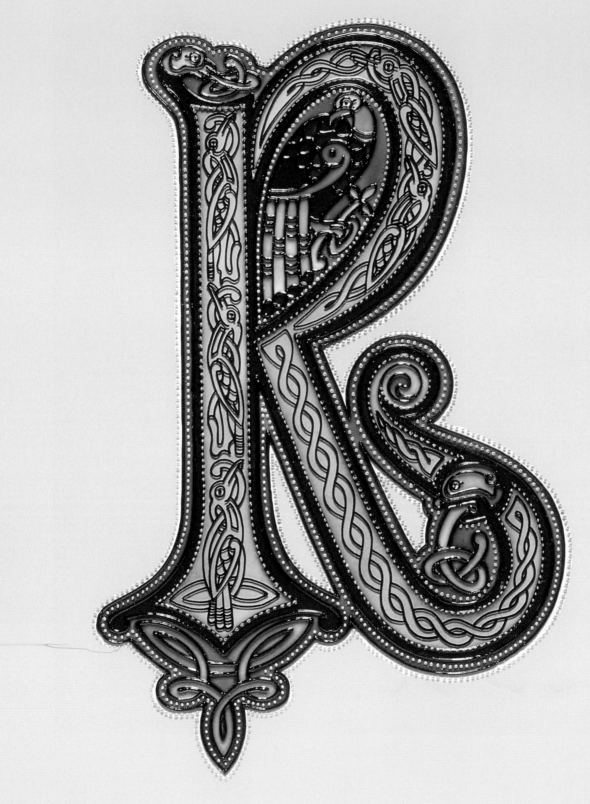

Illuminated Letter

By Judy Balchin

Design, page 90

*This beautiful glass painted letter, inspired by ancient
Celtic manuscripts and ornamentation, combines knotwork
and zoomorphic patterns with a selection of rich, vibrant
colours. The image is outlined with black outliner, painted,
then embellised with penwork and rows of small gold dots.*

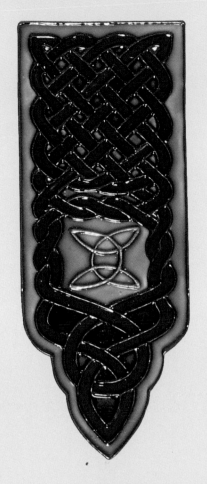

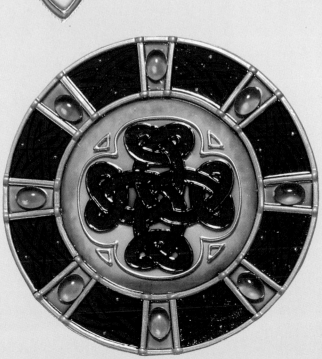

Knotwork Designs

By Judy Balchin

Designs, see page 35

Symbolism is an integral part of Celtic art. The unbroken lines of these interlaced glass painted designs are symbolic of eternal spiritual growth with their never-ending twists and turns. Glass and acetate can be used as a base for these borders, motifs and designs. They are outlined first, then the colours dropped in and allowed to dry before any embellishments are added.

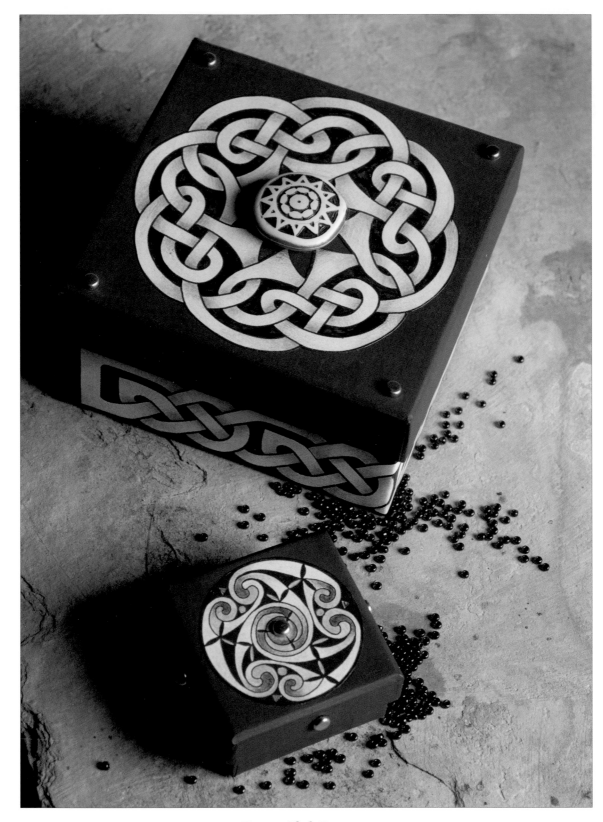

Beautiful Boxes

By Judy Balchin

Design, see pages 30 (top) and 33 (bottom)

The larger box uses knotwork designs as decoration and the smaller box uses a spiral motif. They are both painted with acrylic paints and embellished with gold brads. The designs are then photocopied, coloured with pencil crayons, cut out and glued into place. A decorative bead is used to complete the central knotwork design and a brad completes the smaller spiral design.

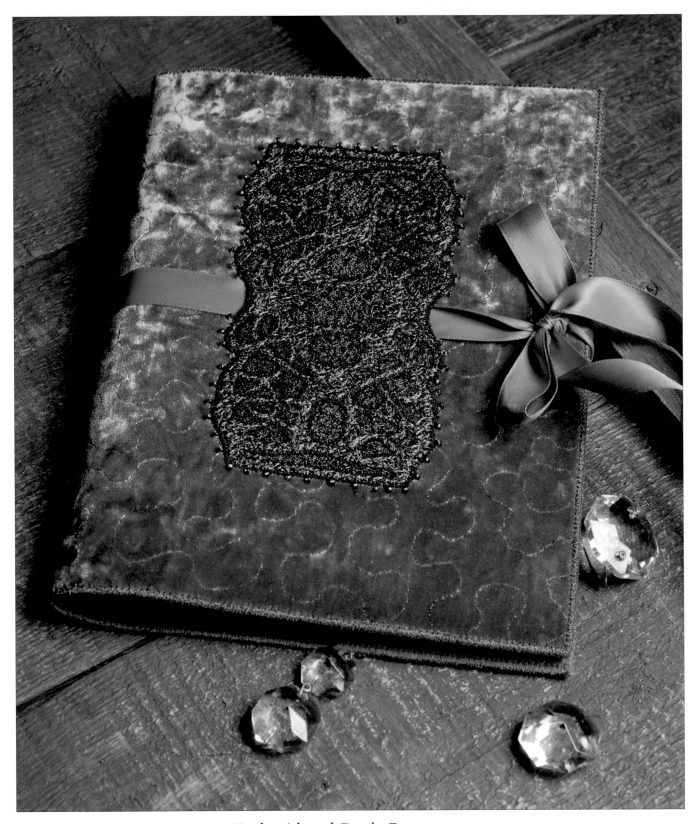

Embroidered Book Cover

By Jenny Rolfe

Design, see page 45

Celtic designs are perfect for embroidery projects. The central panel design on this dyed velvet cover has been chosen to complement the shape and size of the book. The original illustration is enlarged slightly, photocopied, cut out and coloured. It is then placed between two layers of water soluble film and a fine pen is used to trace the design on to the film. The photocopy is removed and the black outline areas are free machine stitched, then the rest of the design is filled in with coloured threads, following the original planned colours.

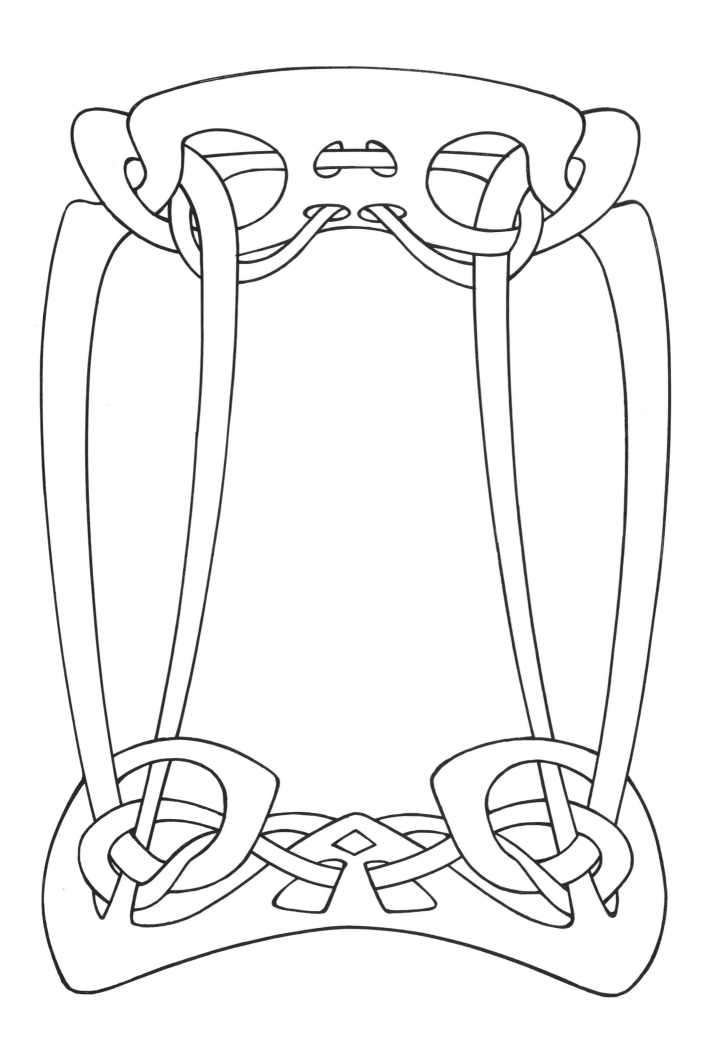

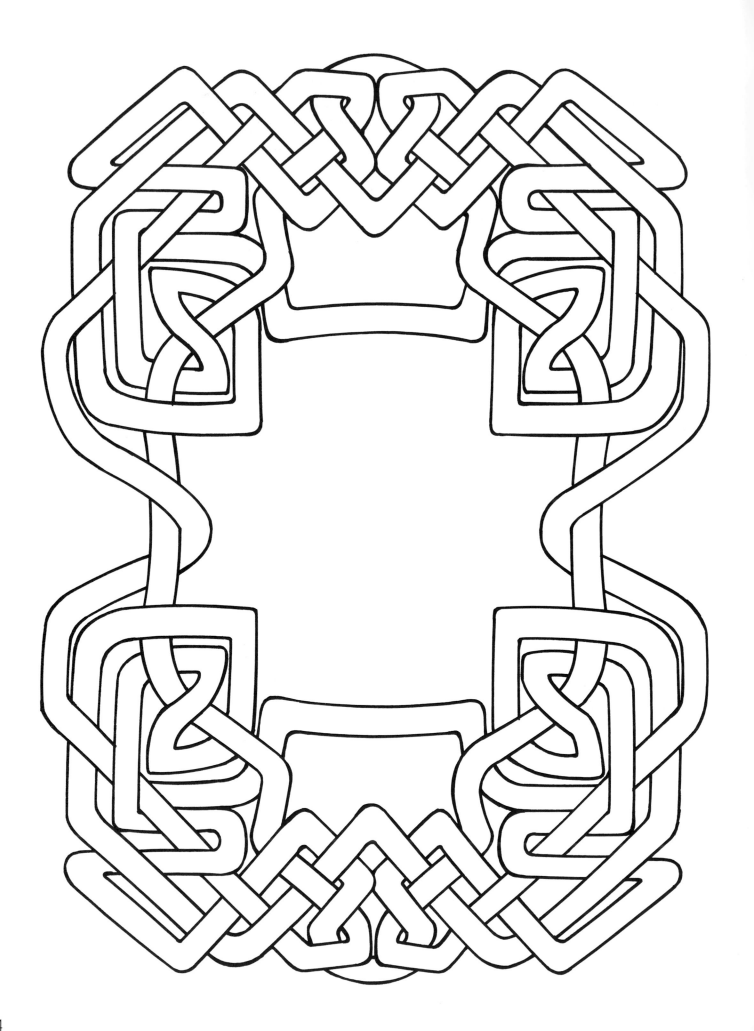

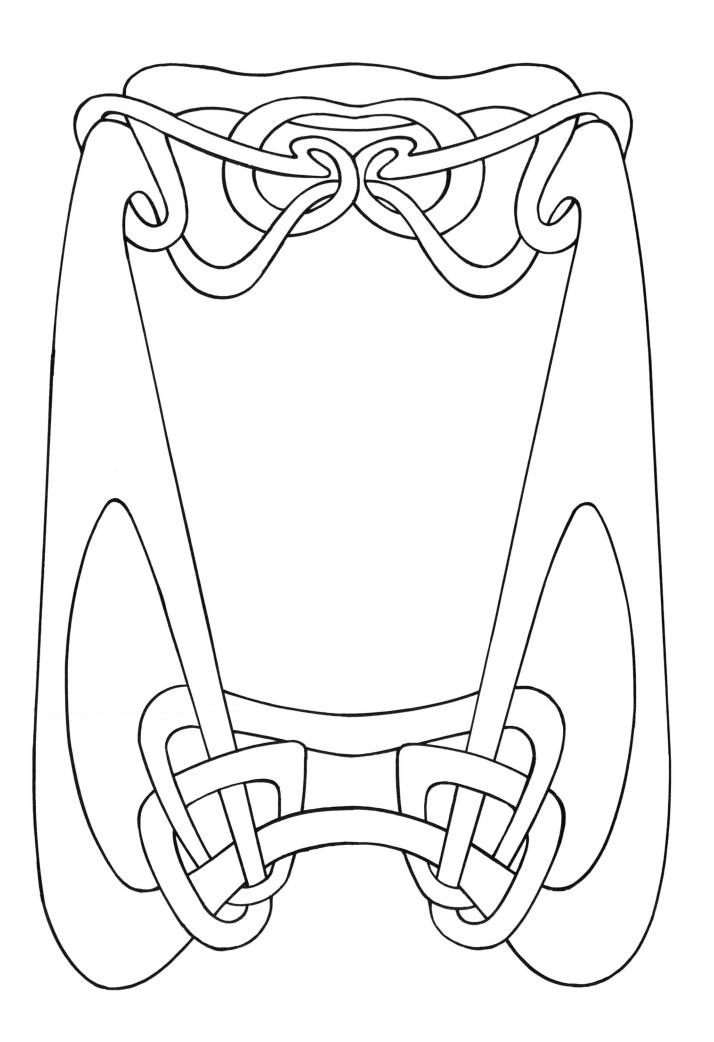

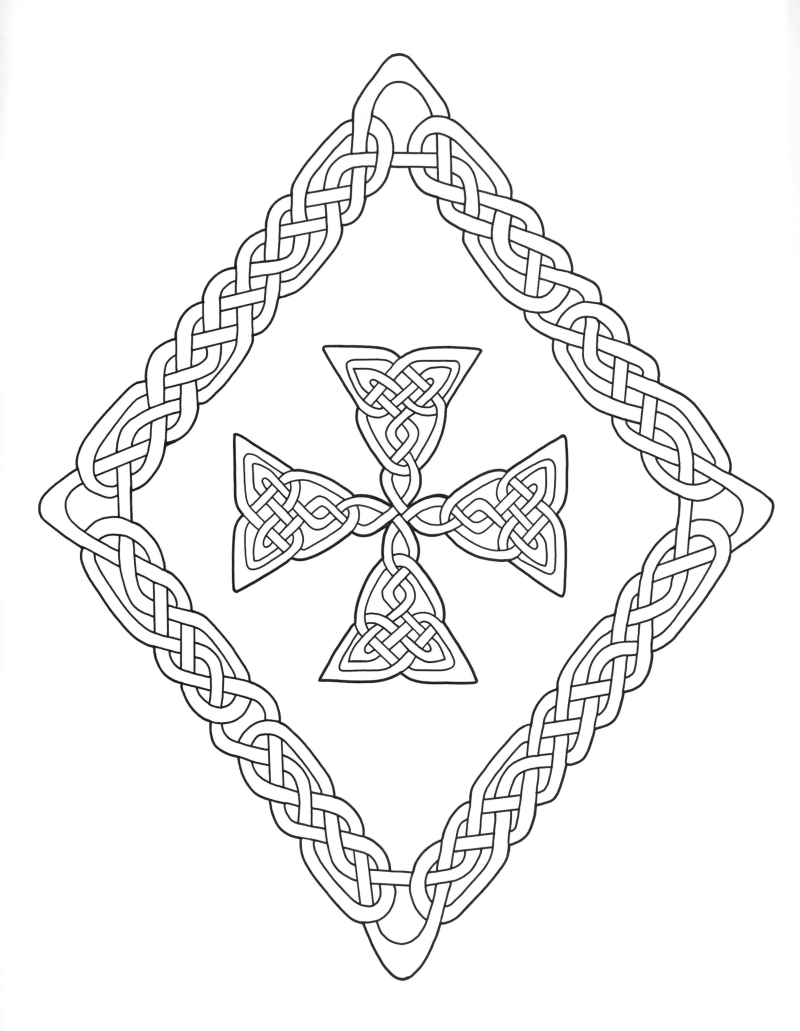

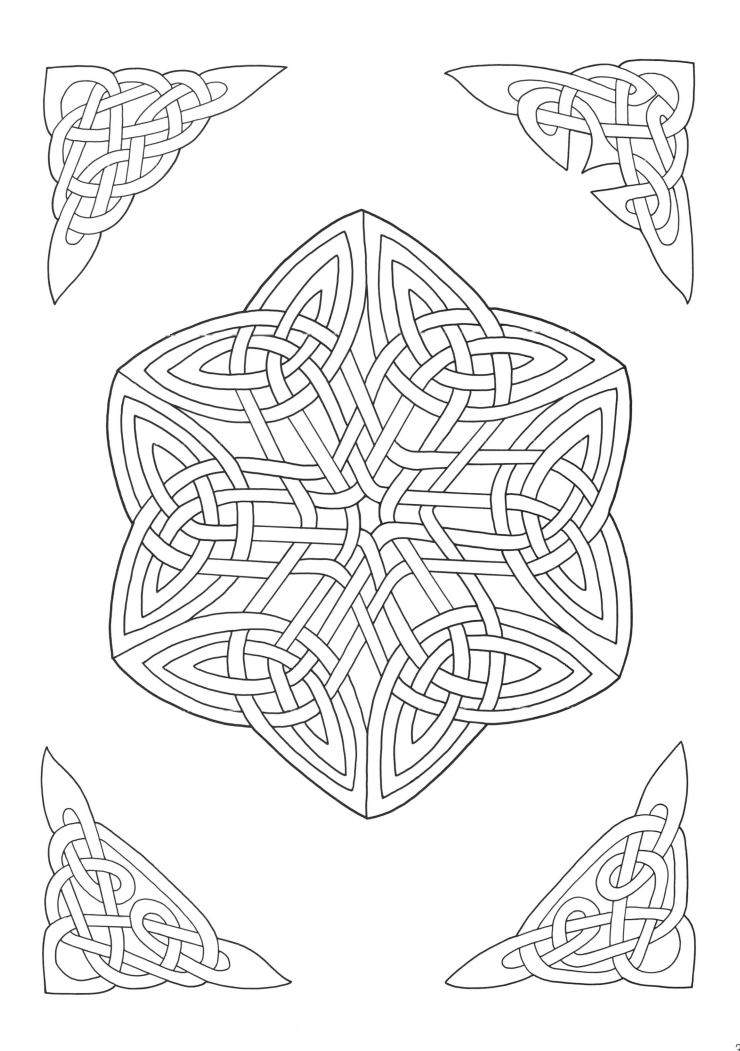

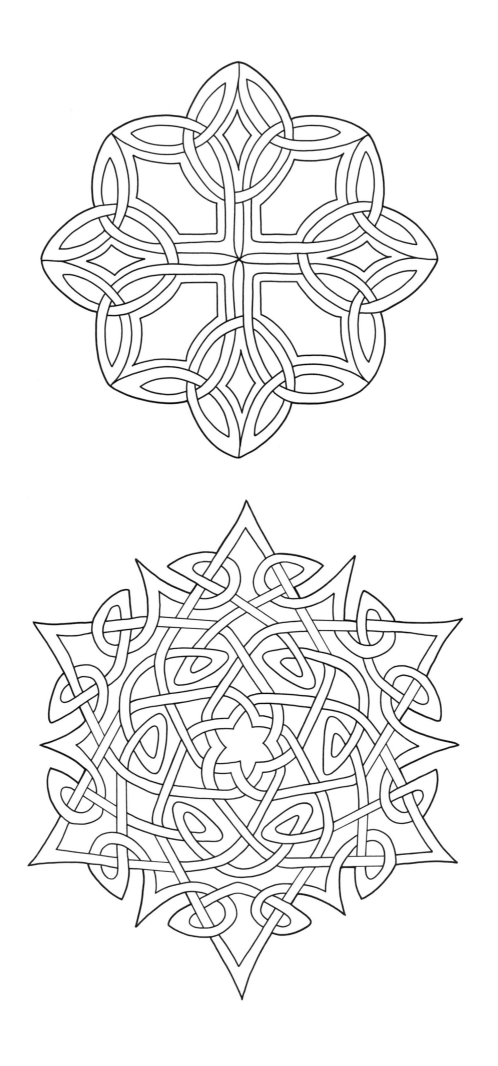

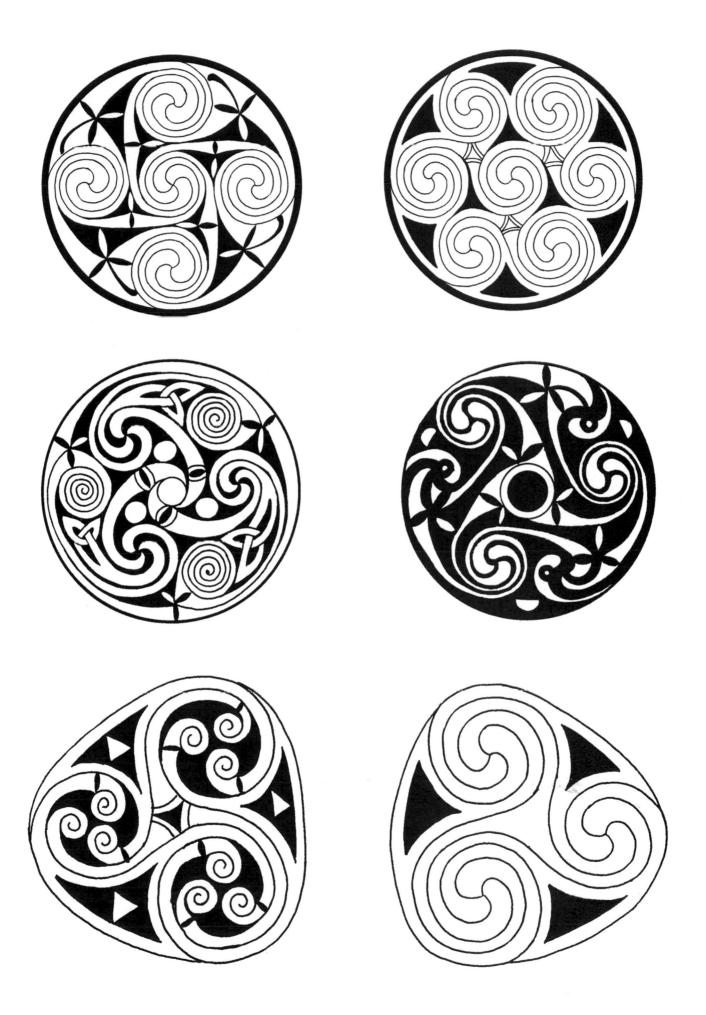

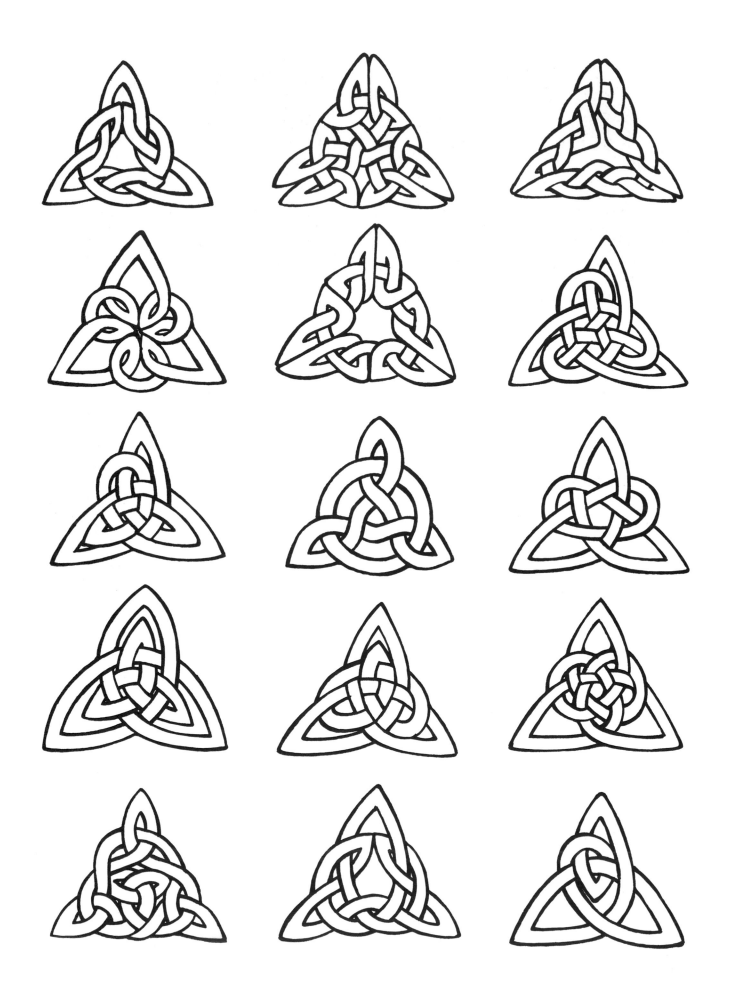

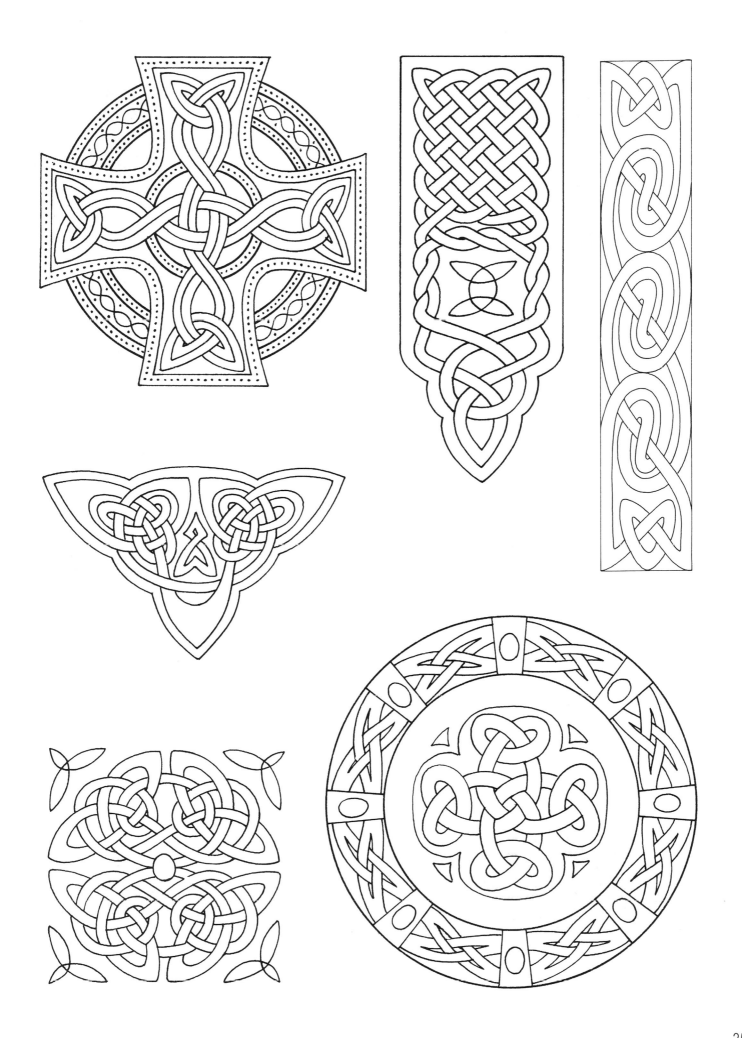

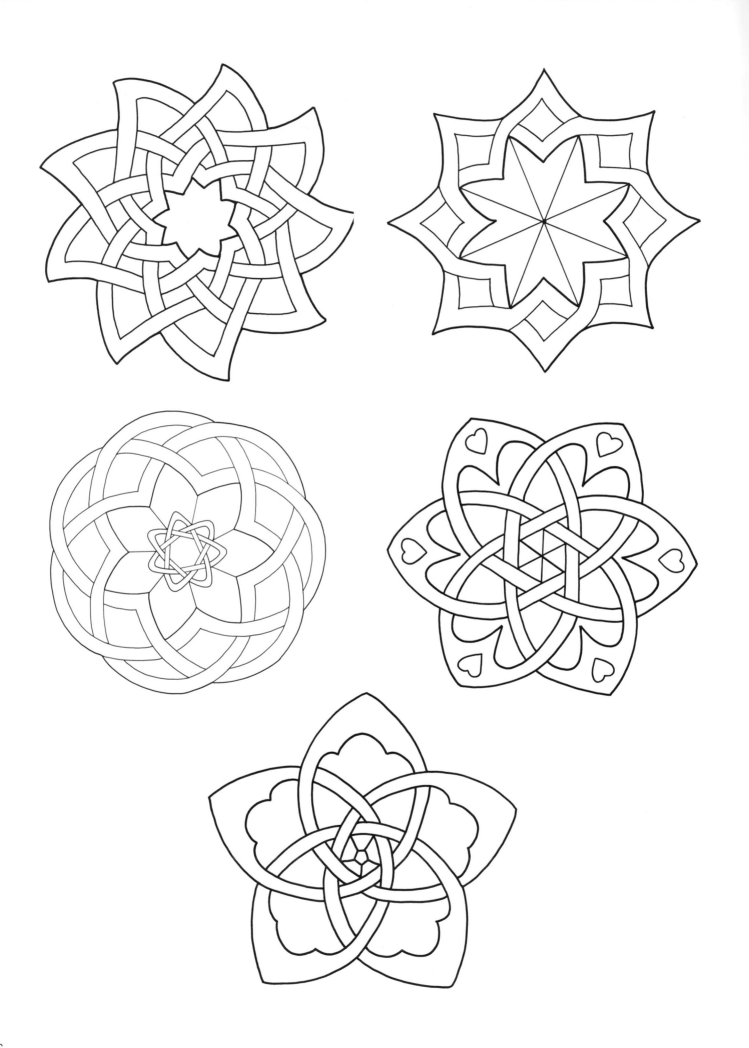

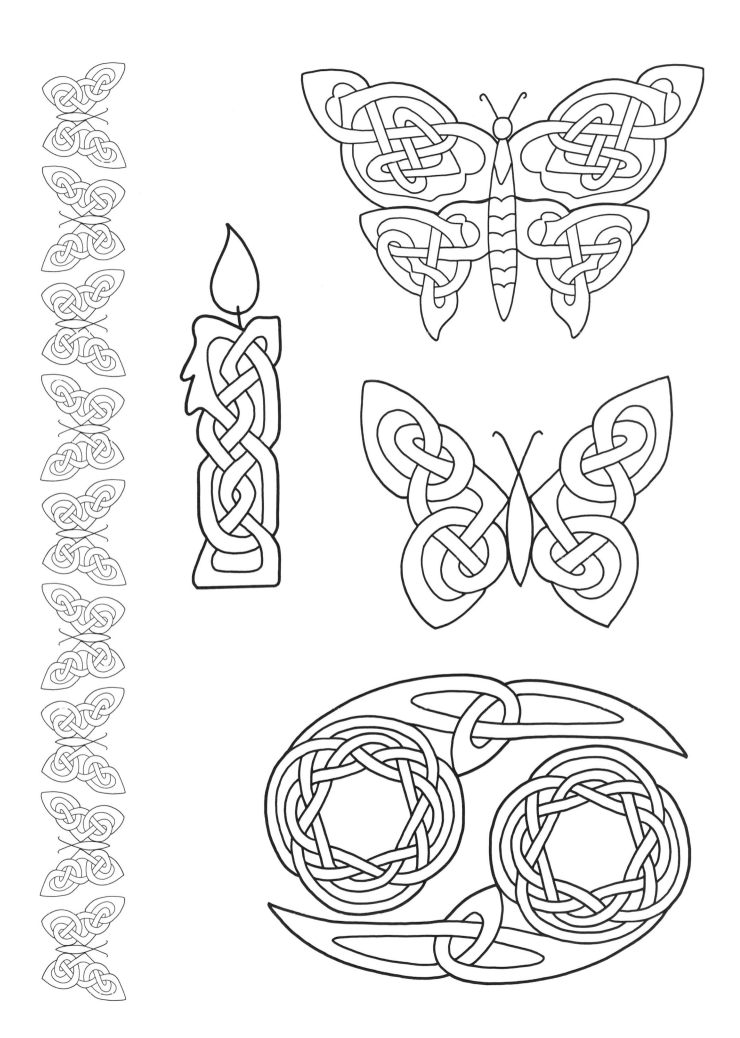

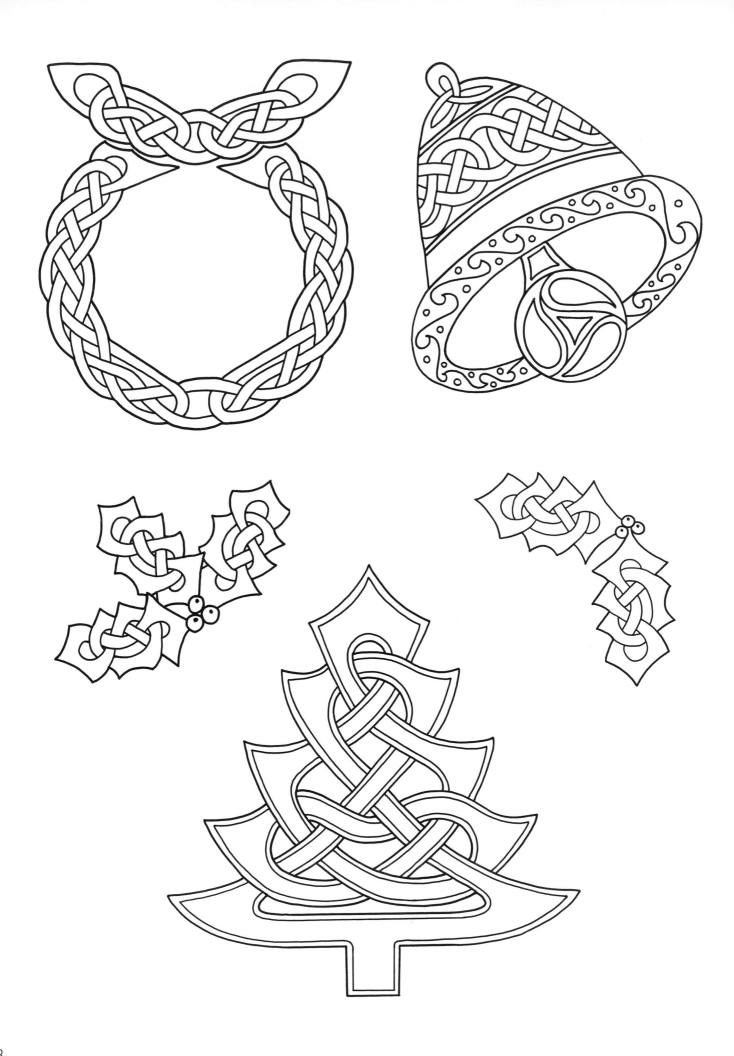

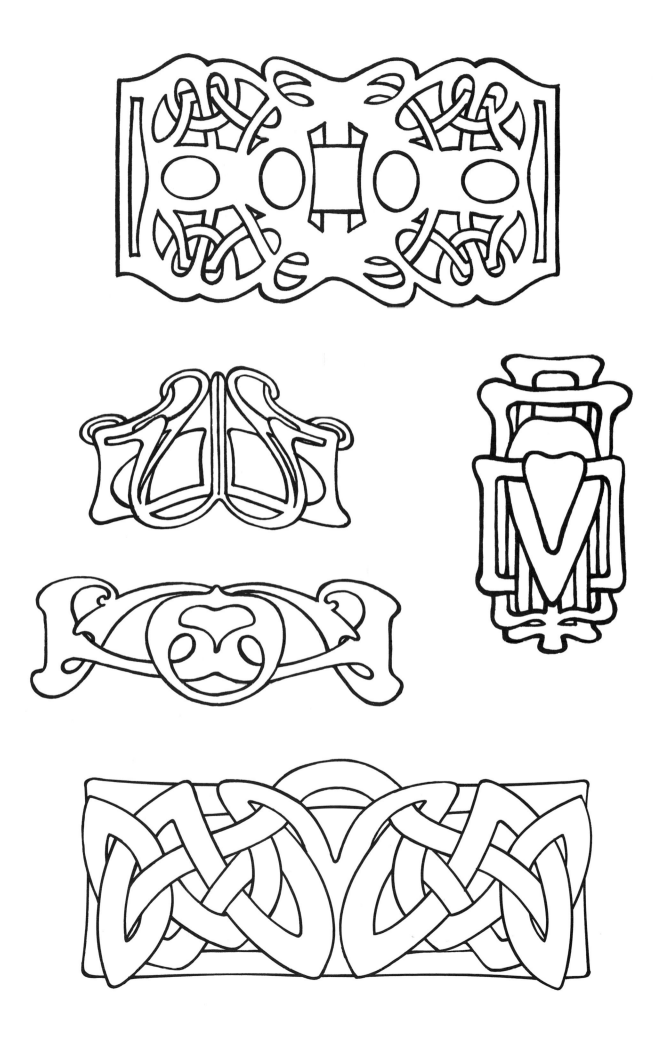

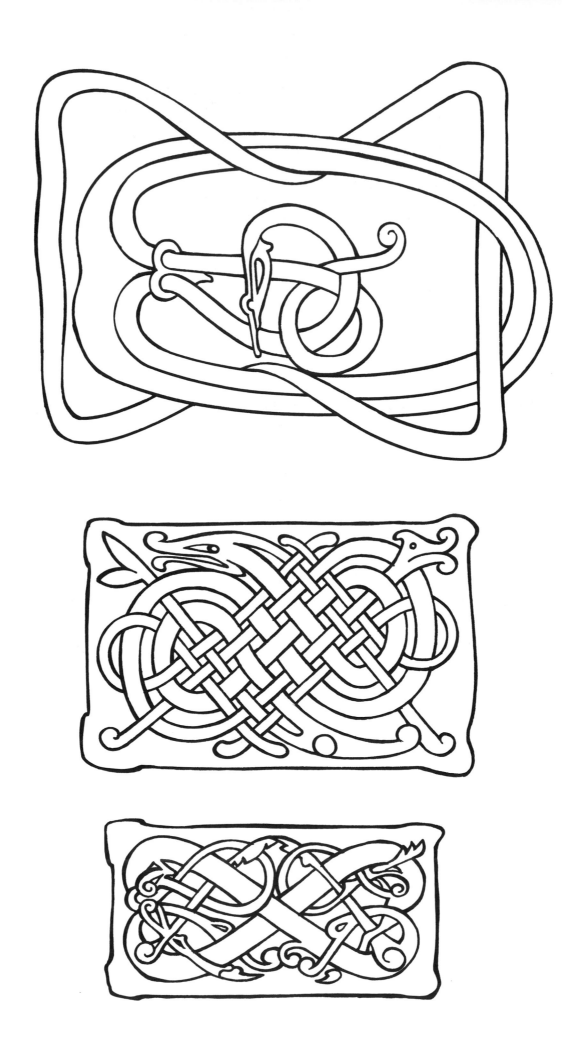

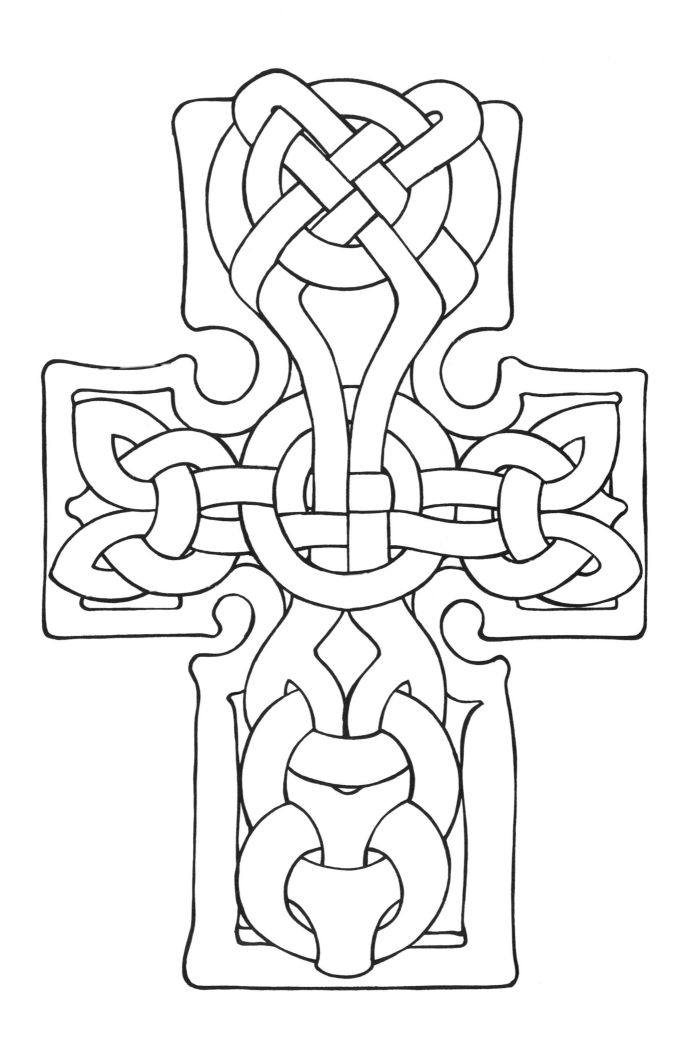

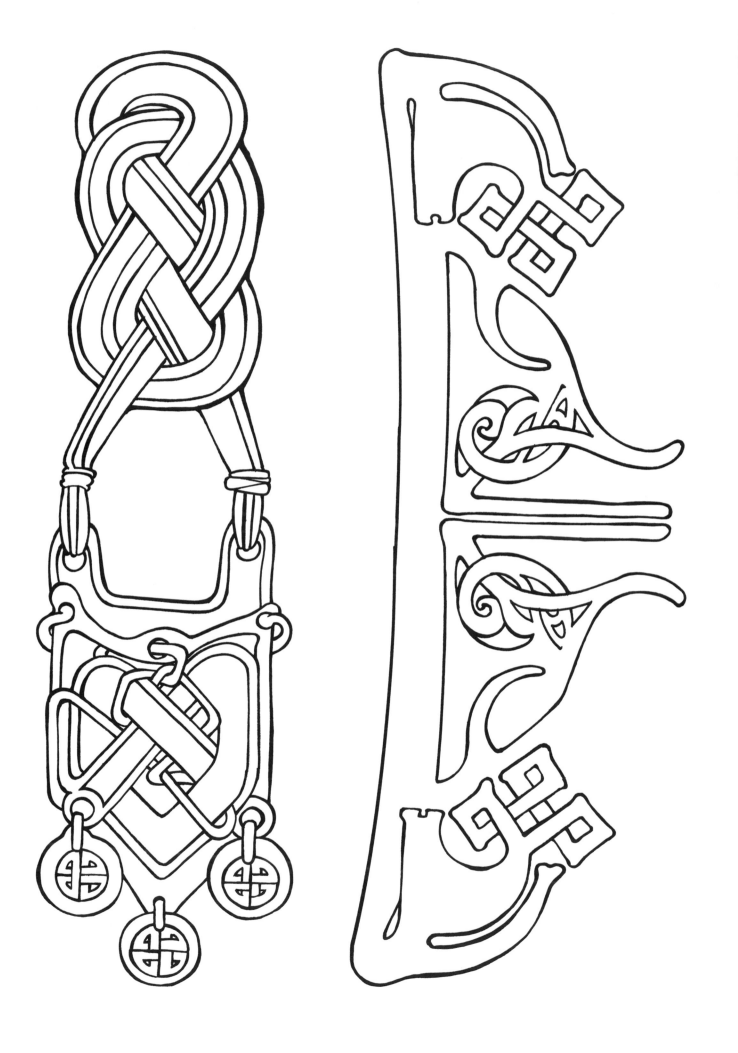

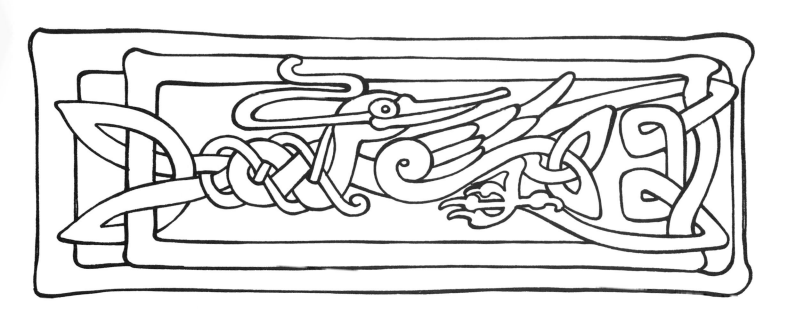

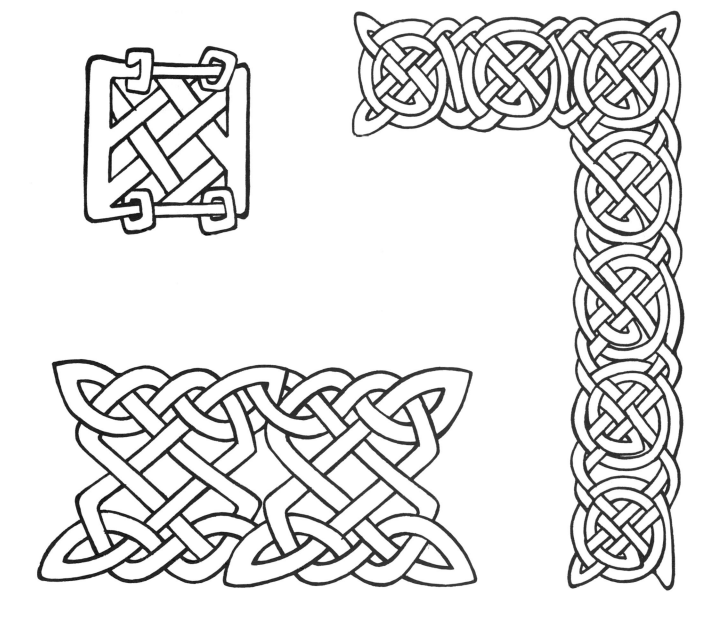

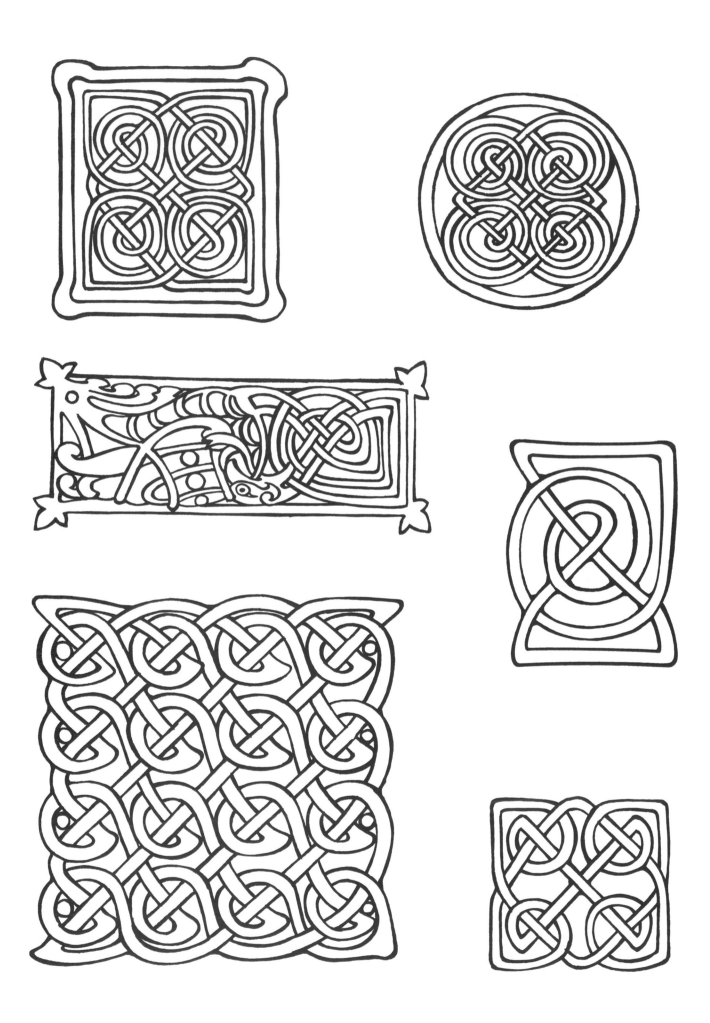

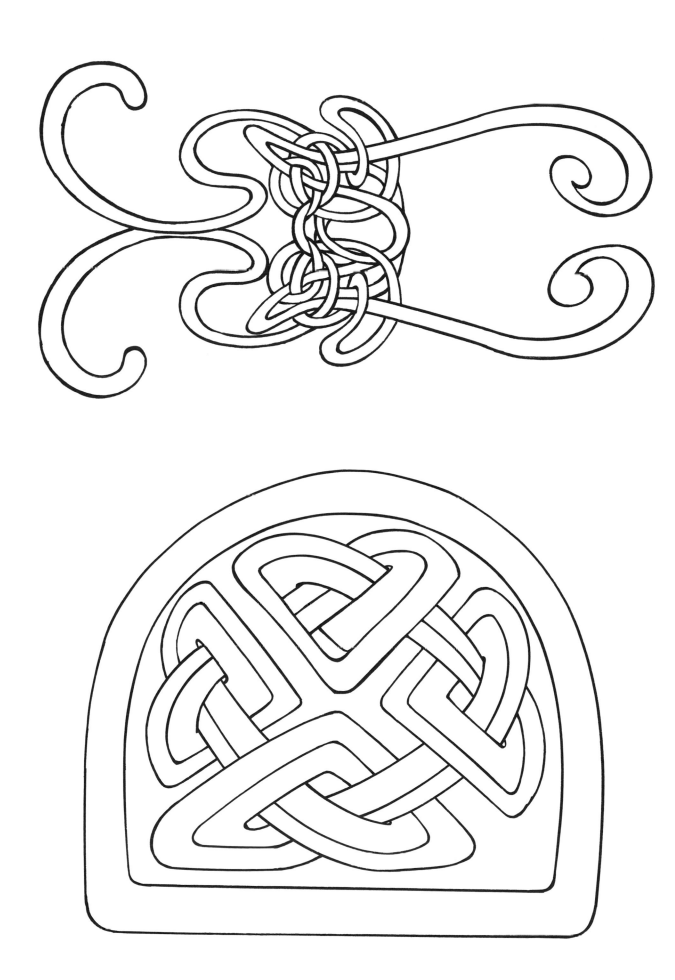

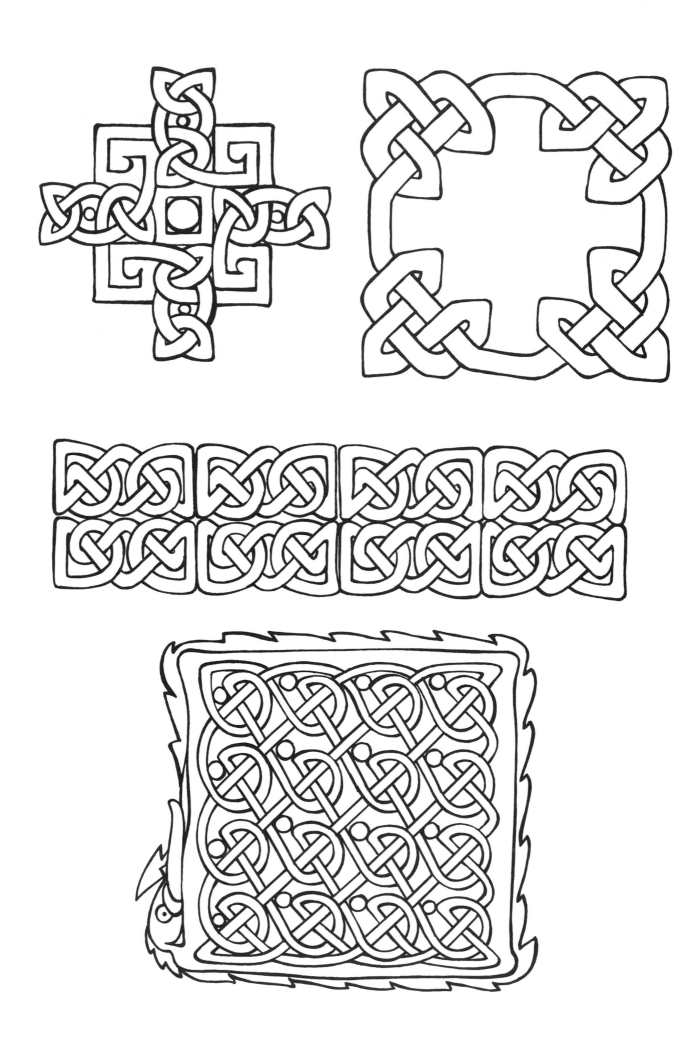

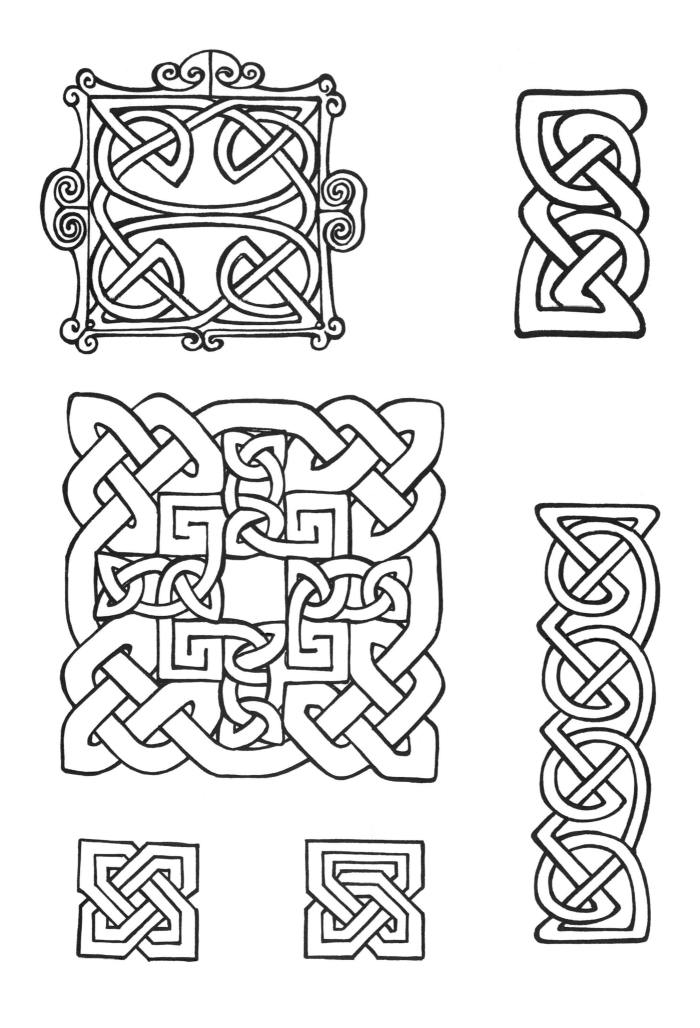

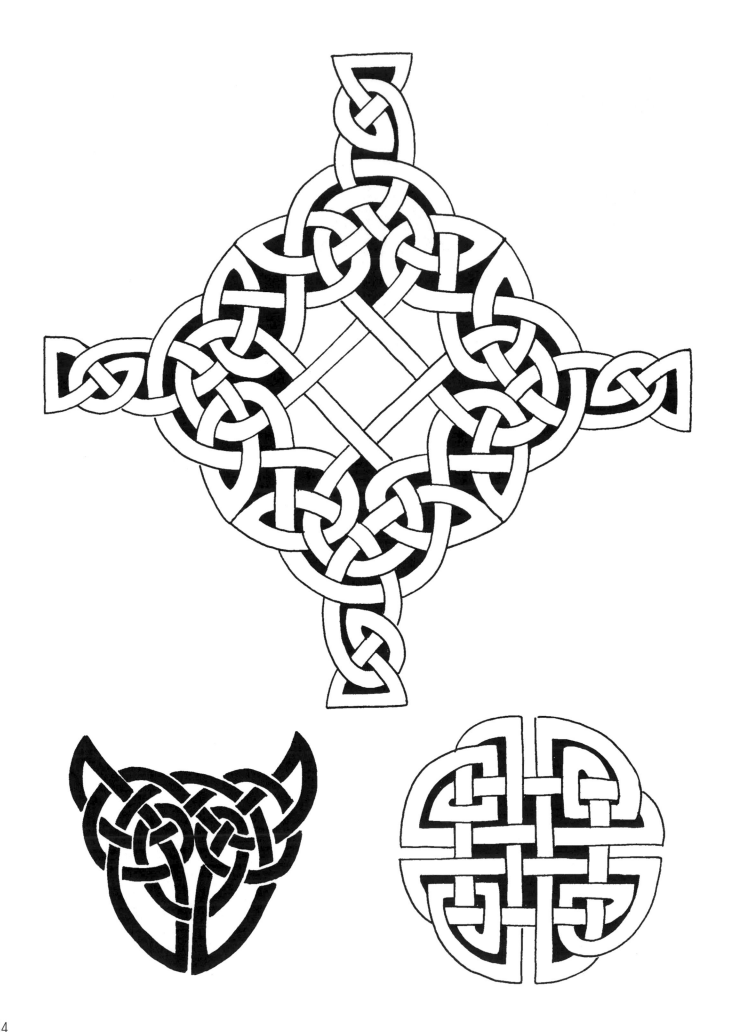

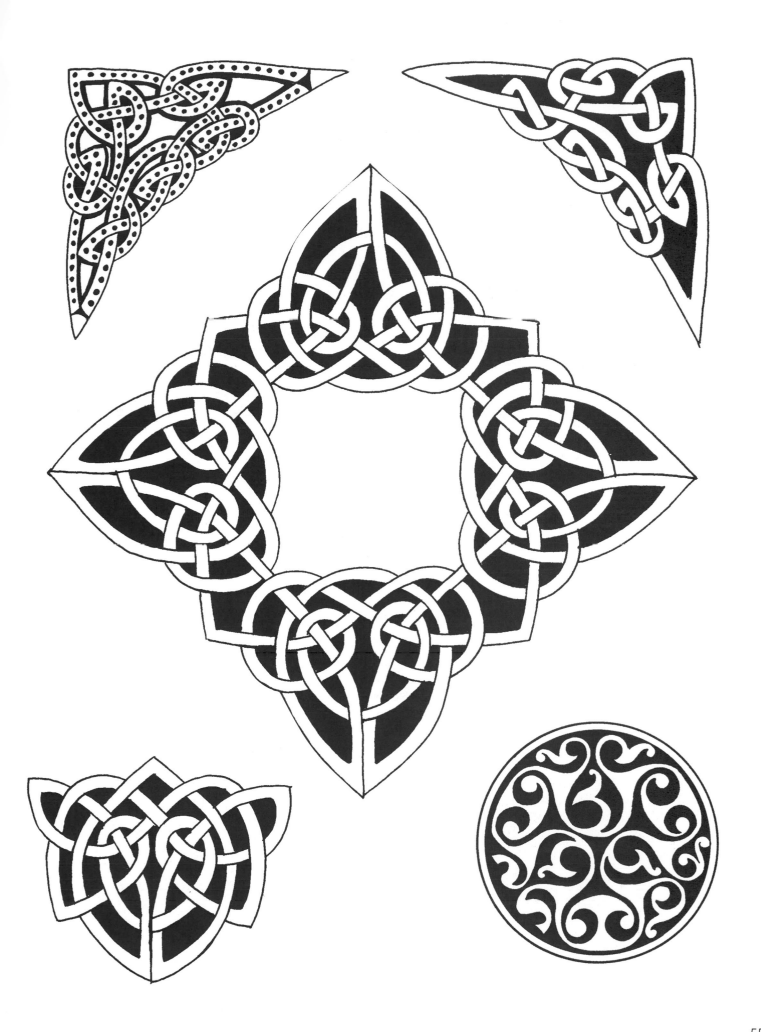

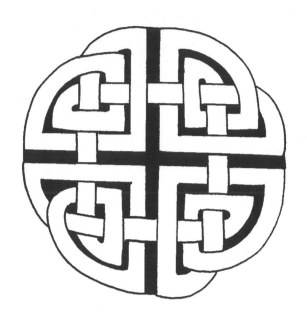

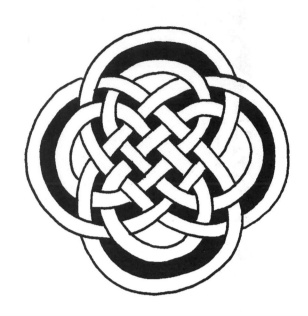

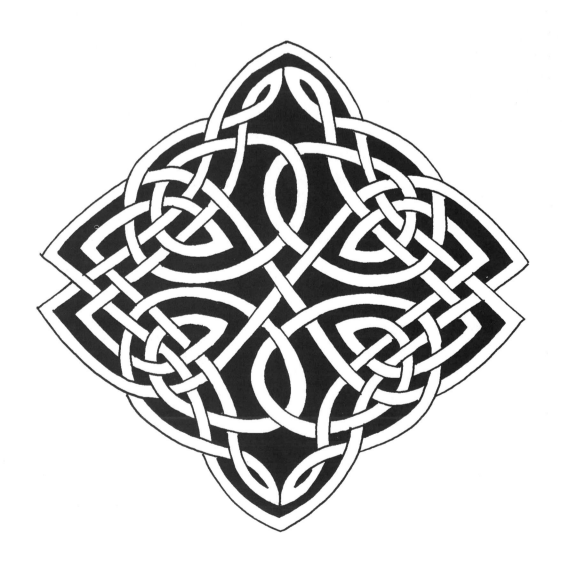

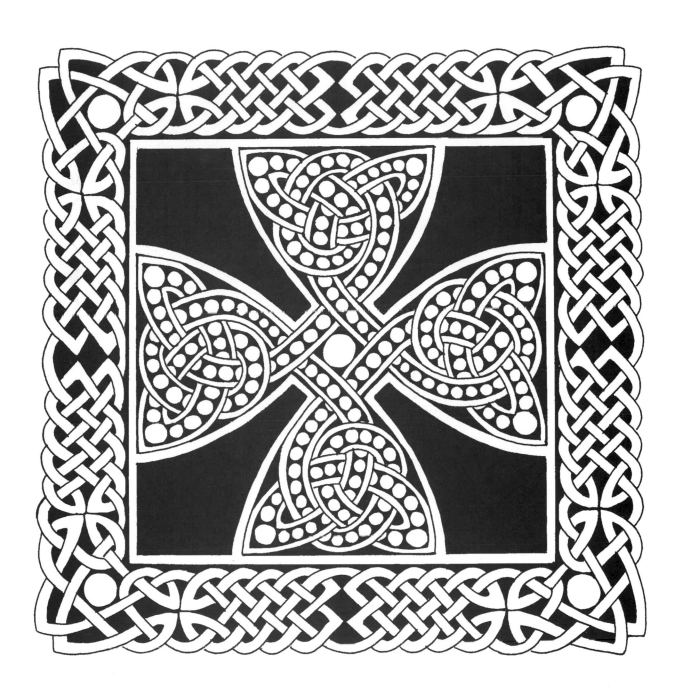

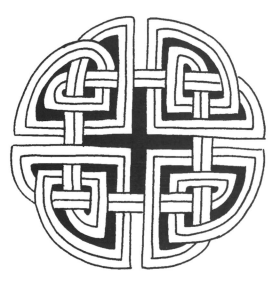 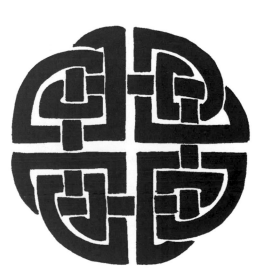

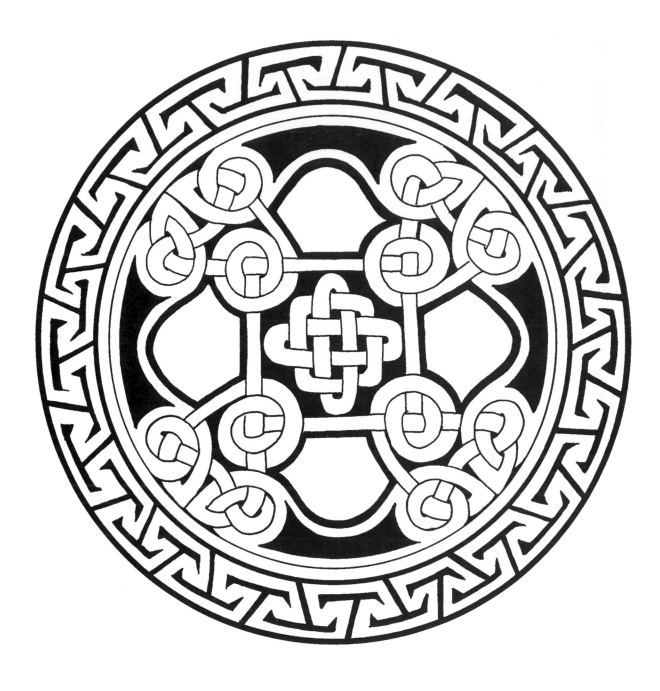

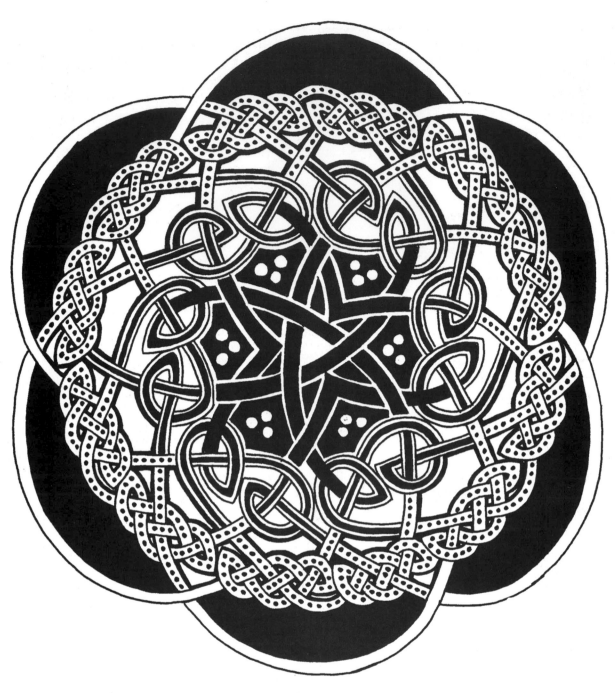

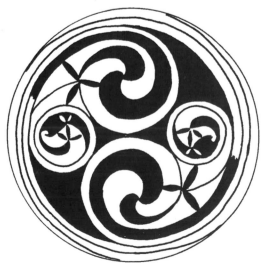

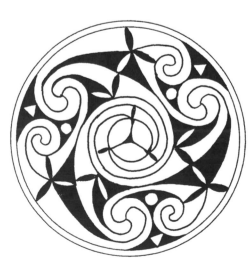

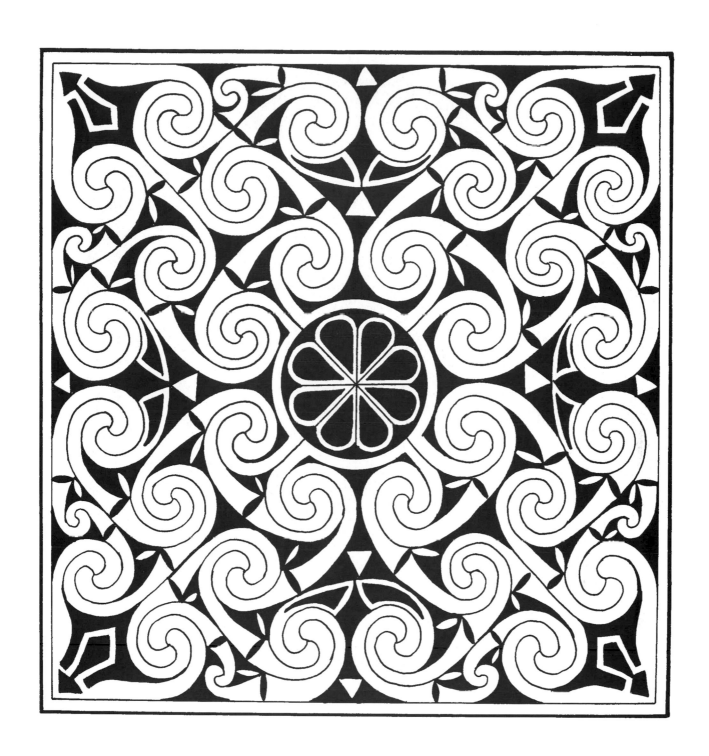

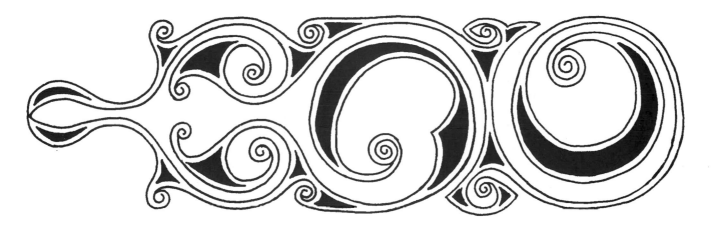

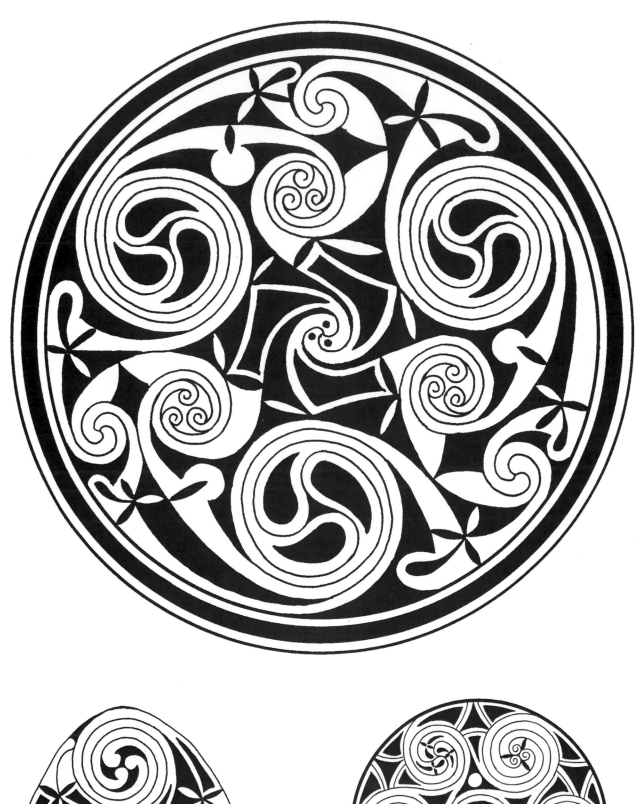

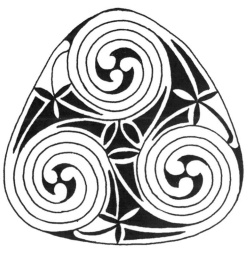

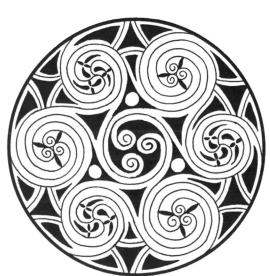

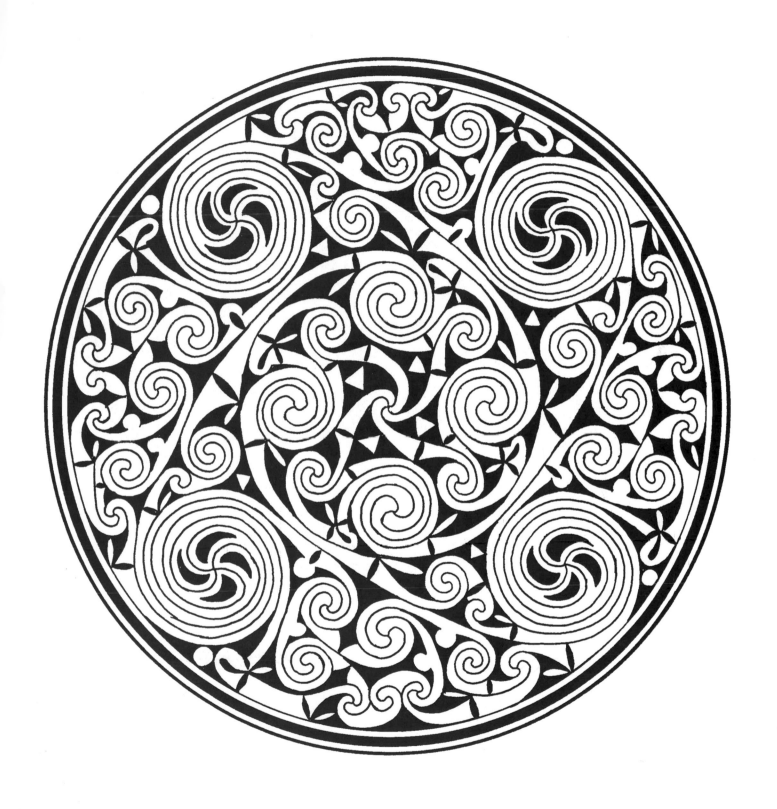

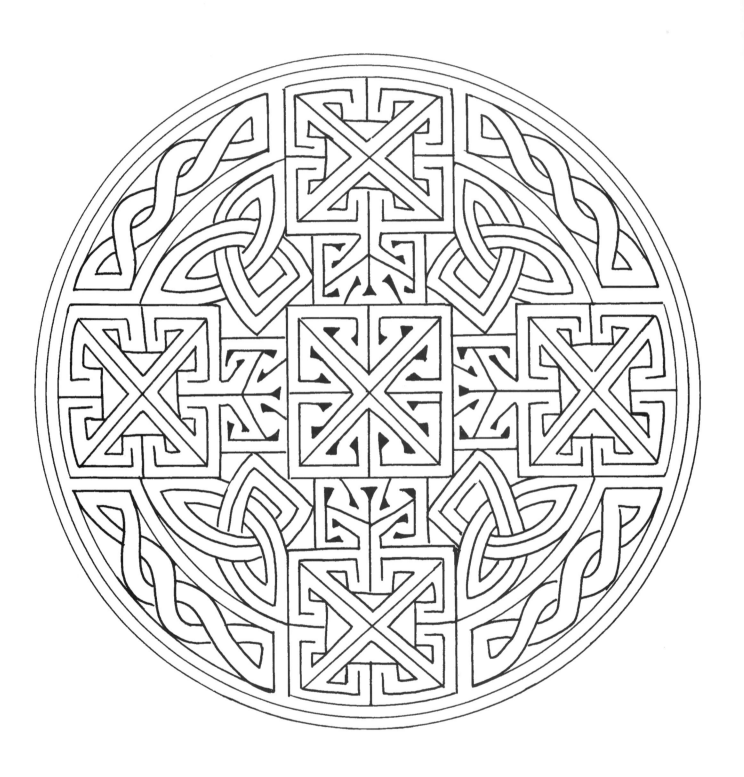

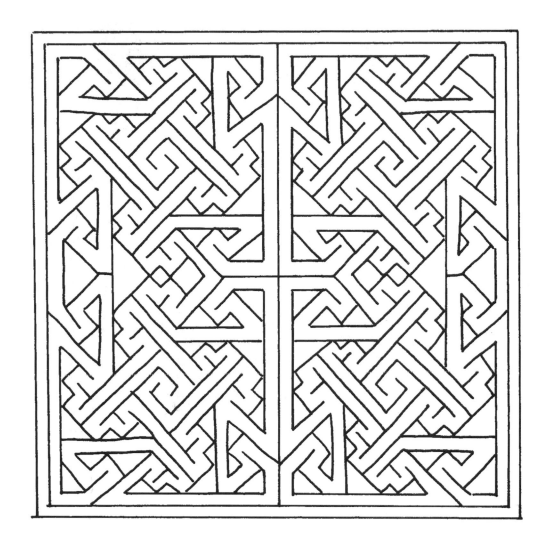

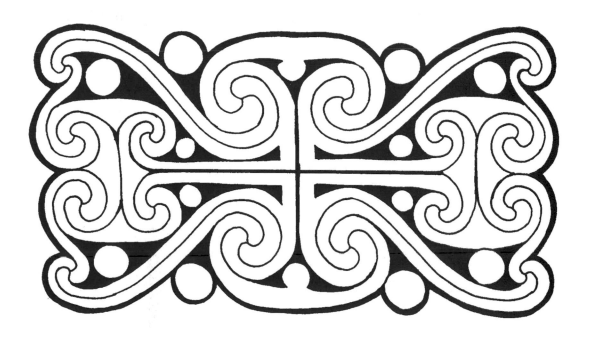

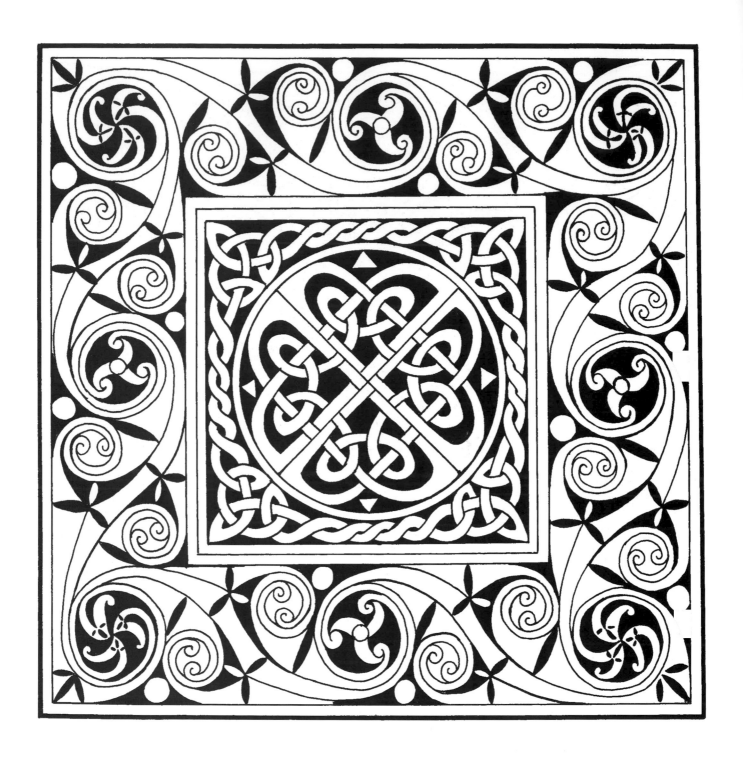

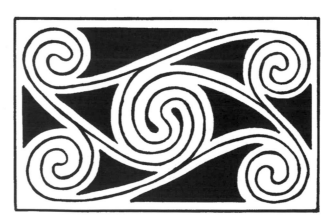

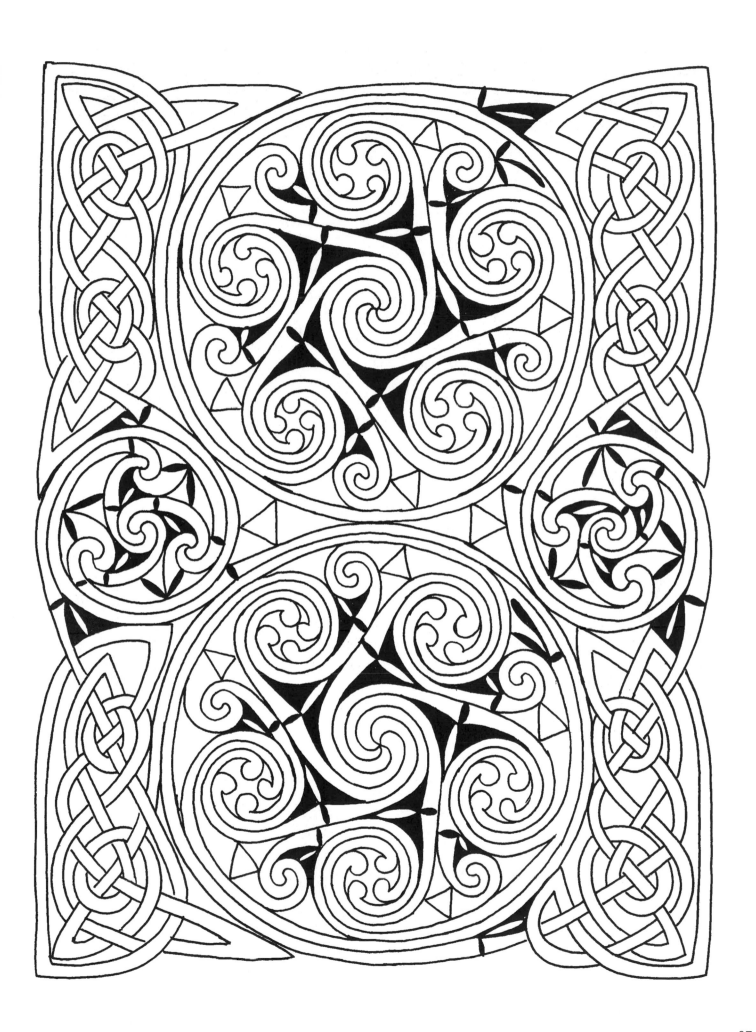

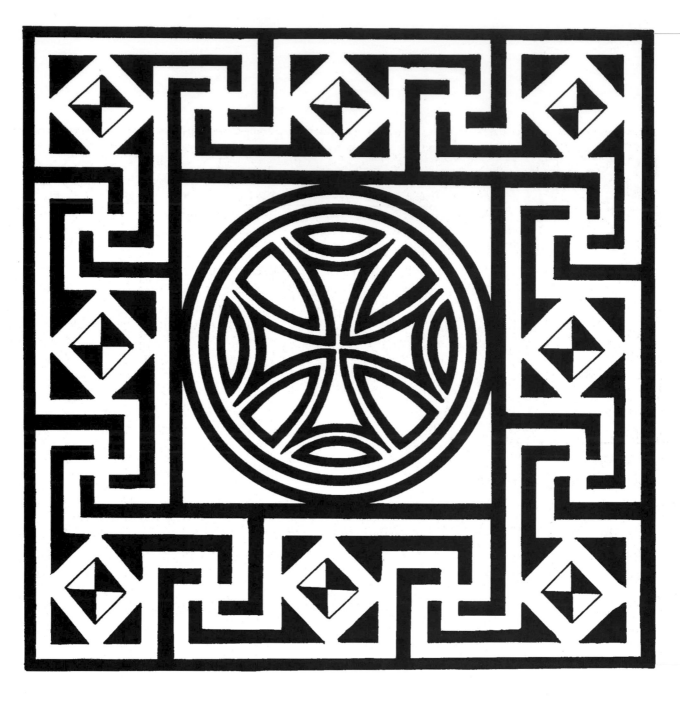

 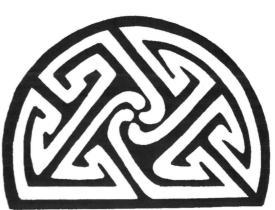

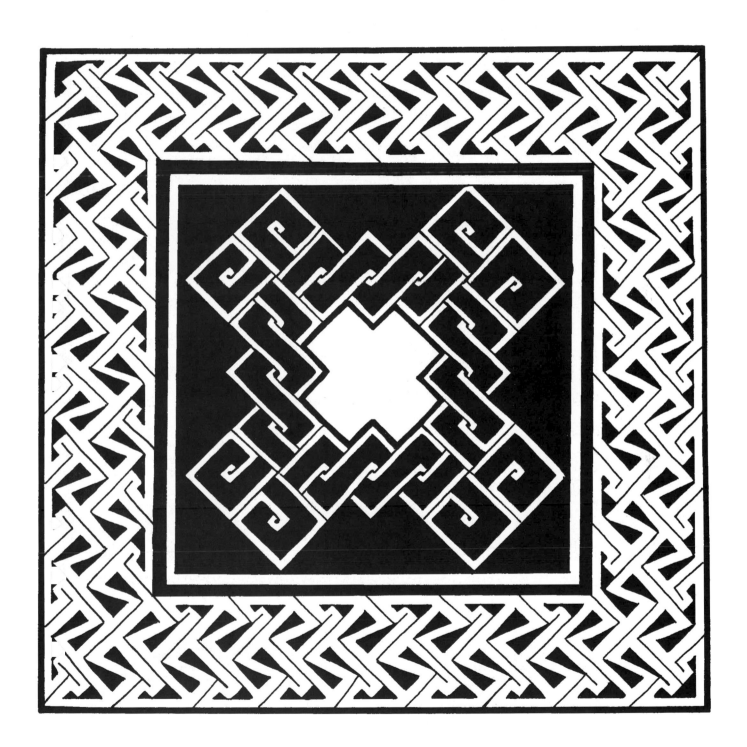

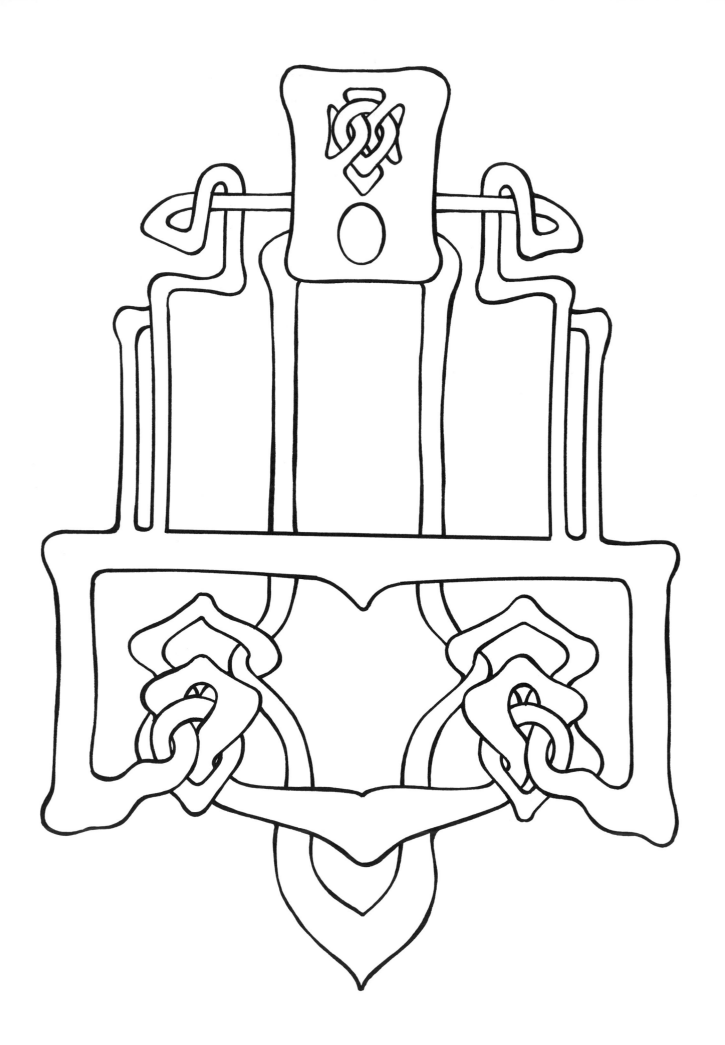

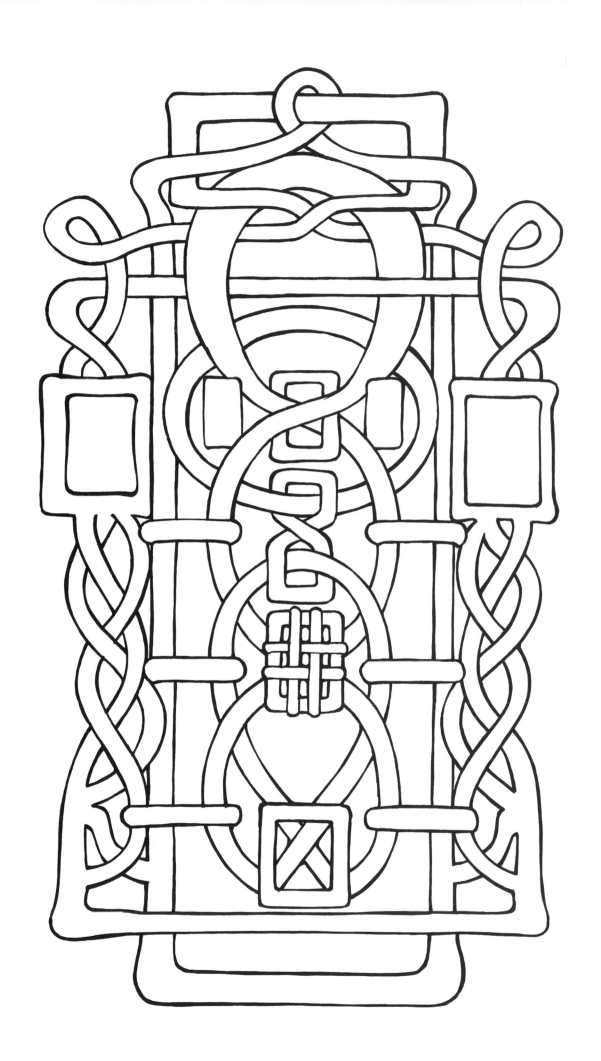

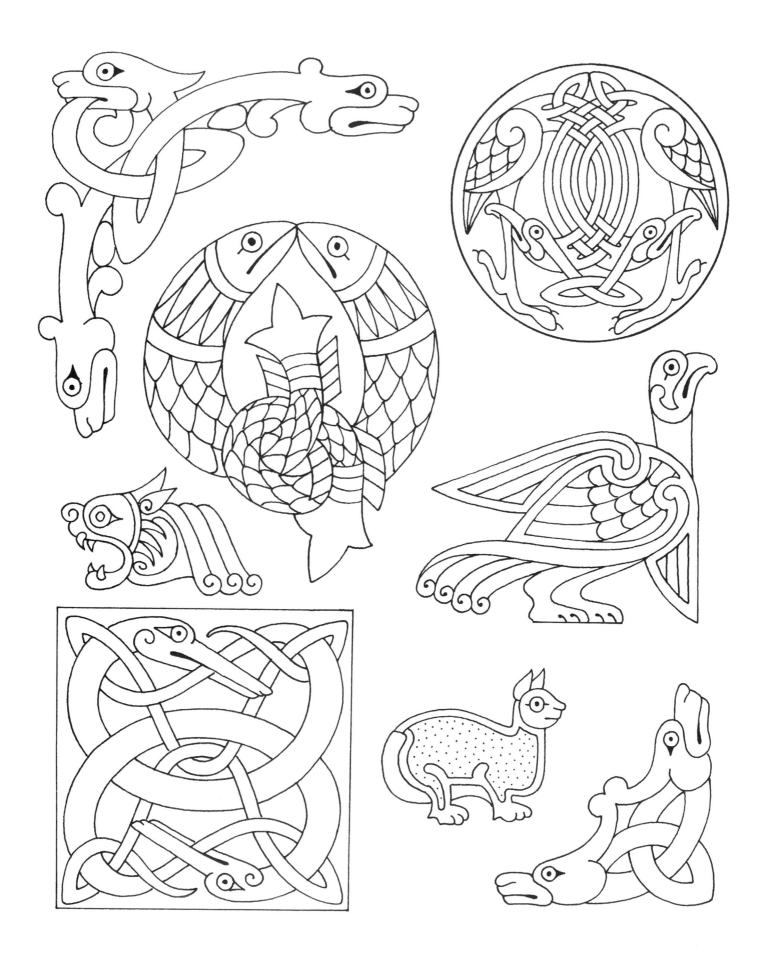

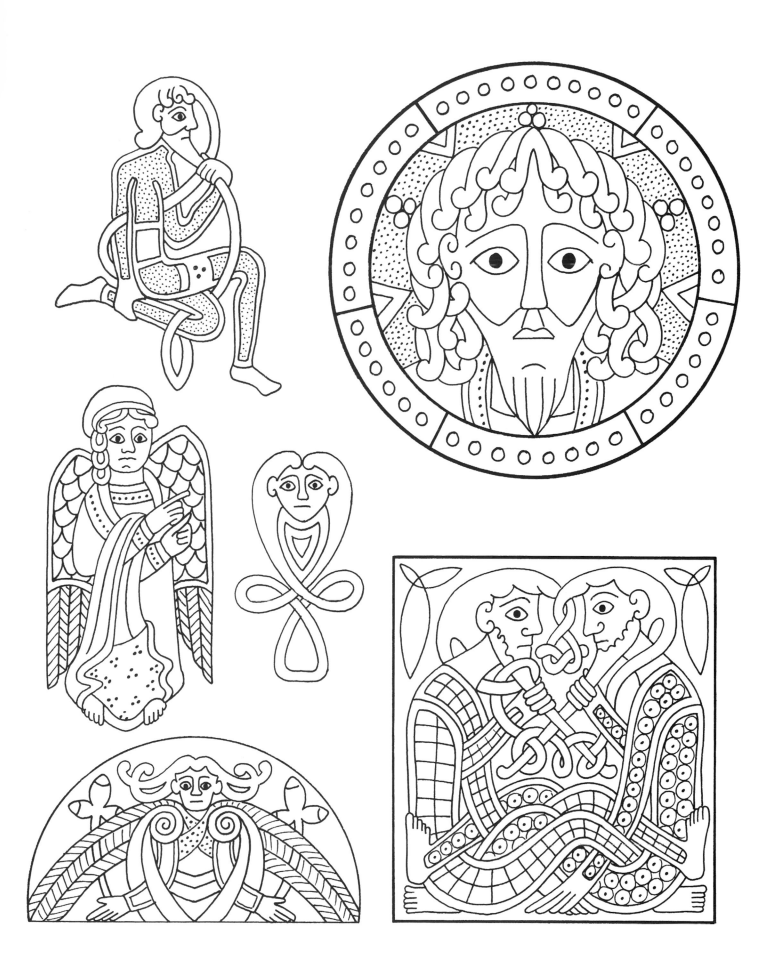

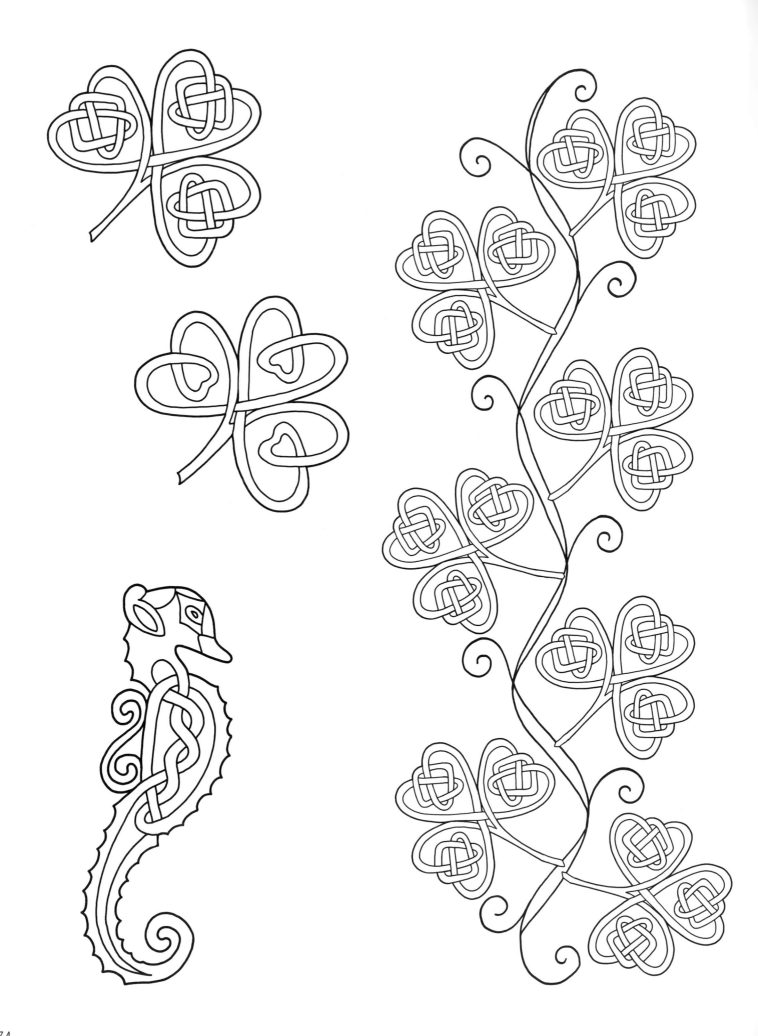

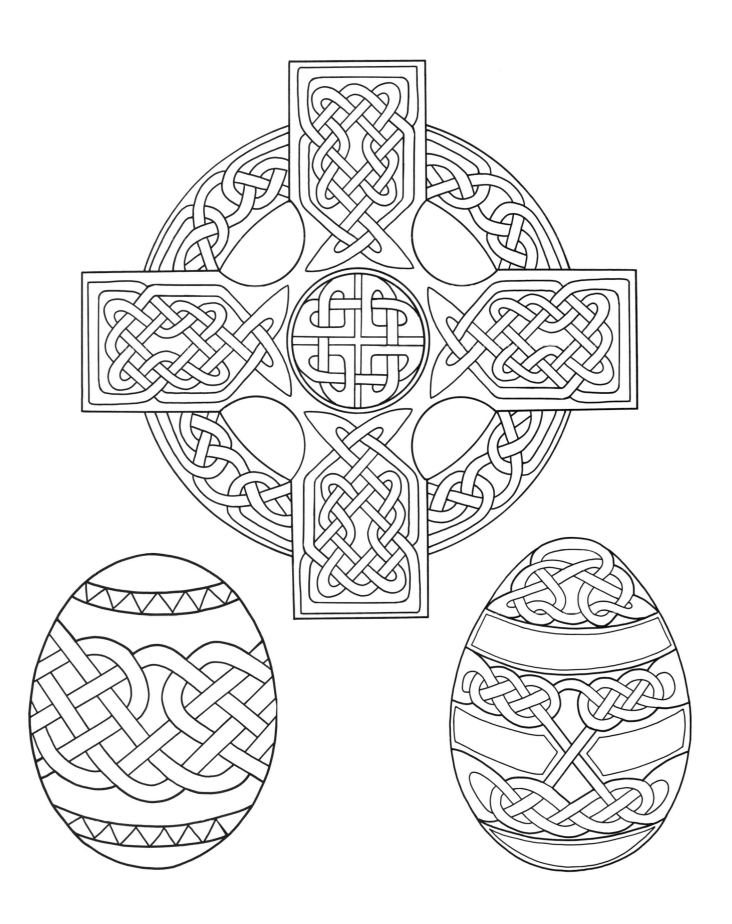

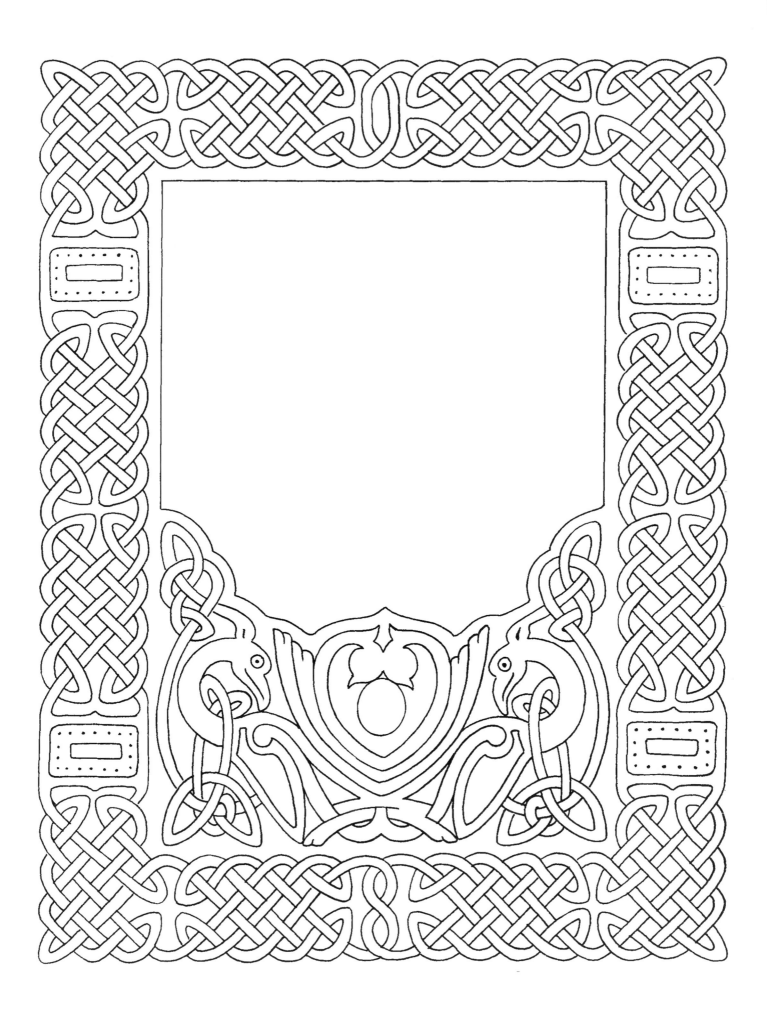

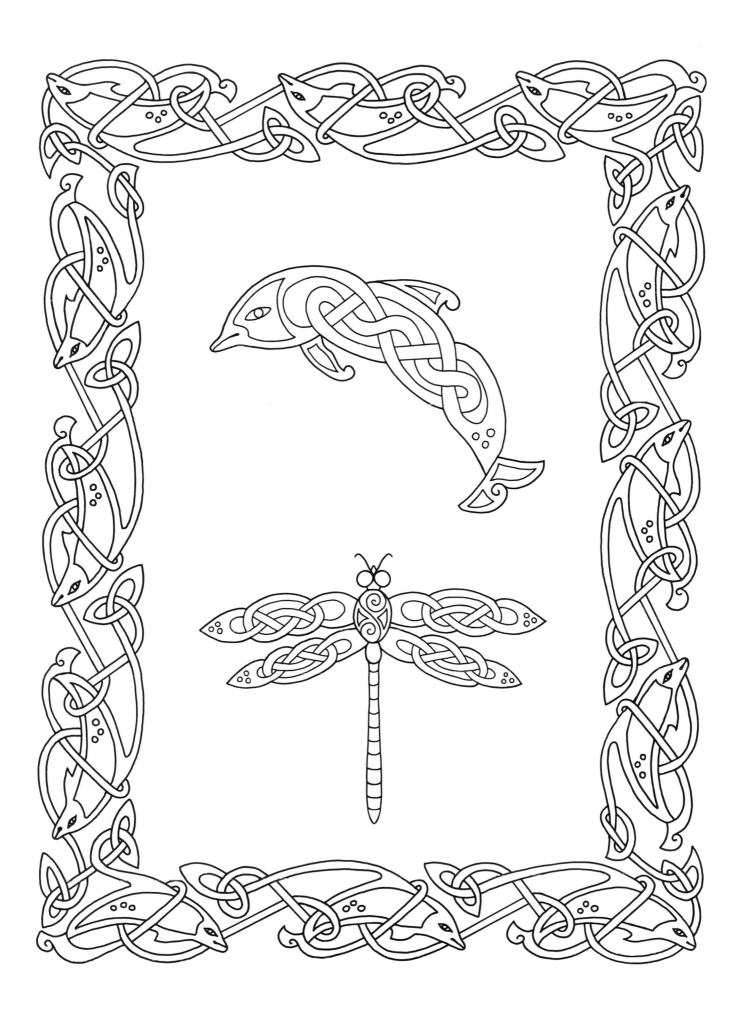

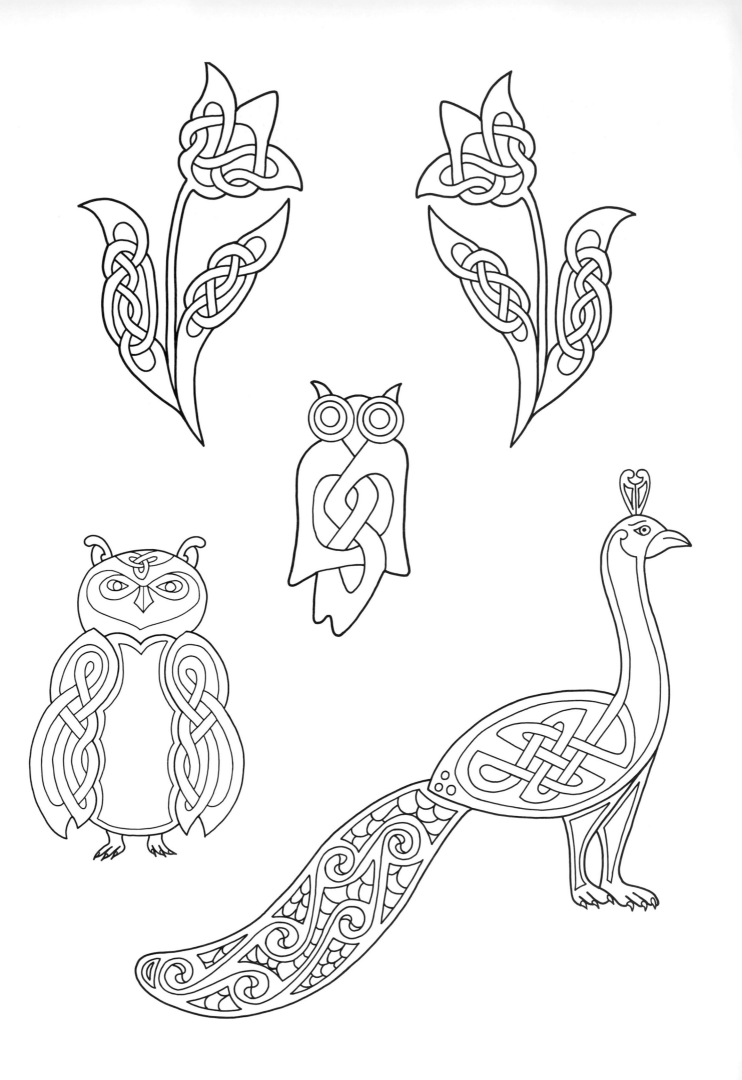

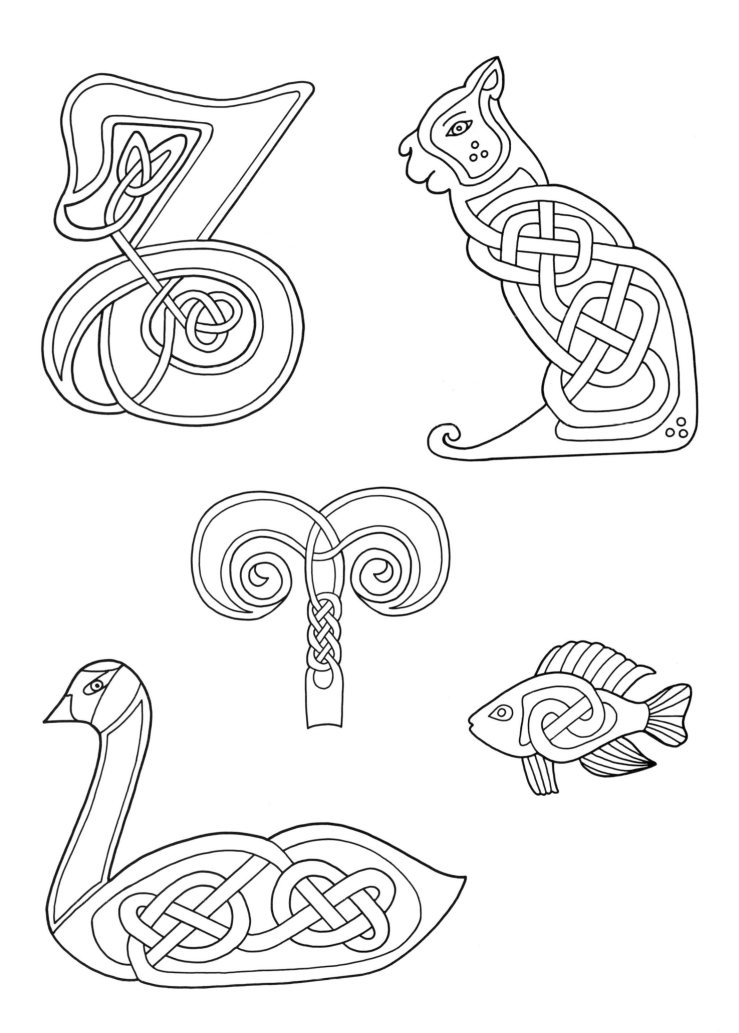

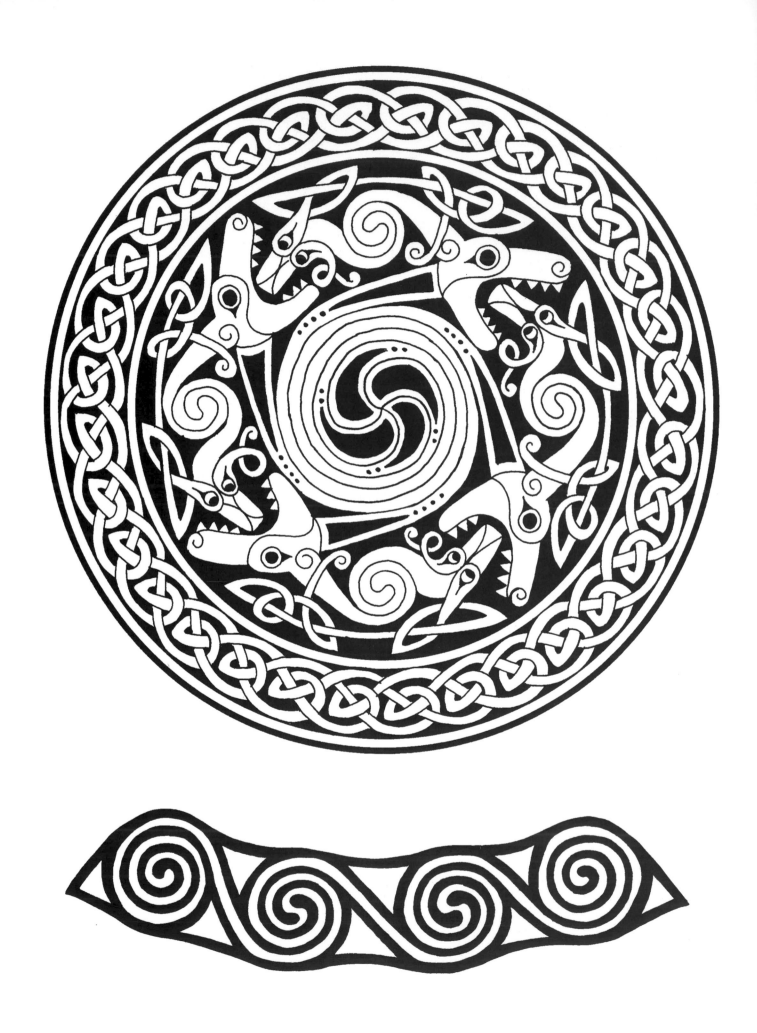

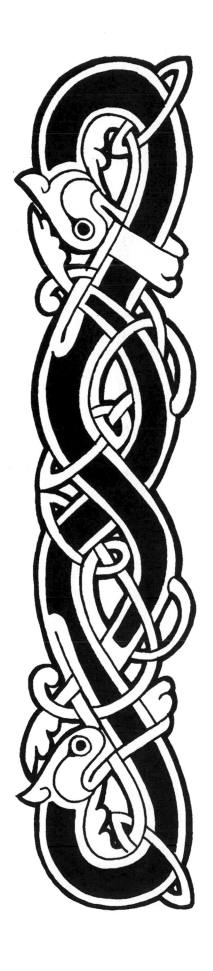
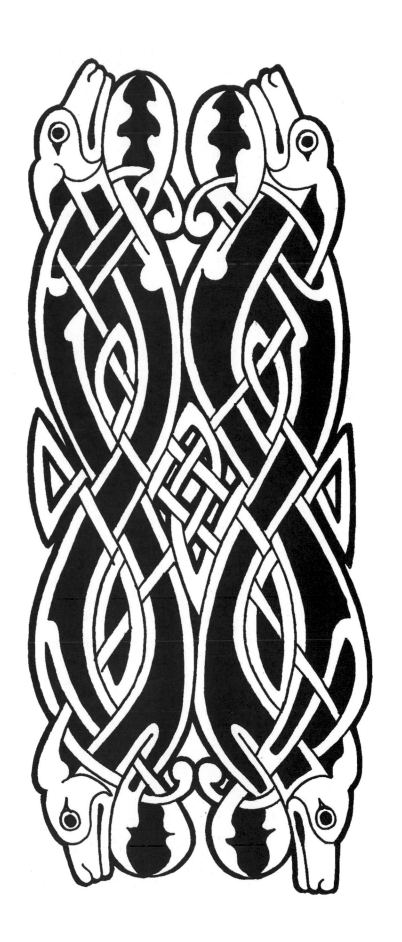

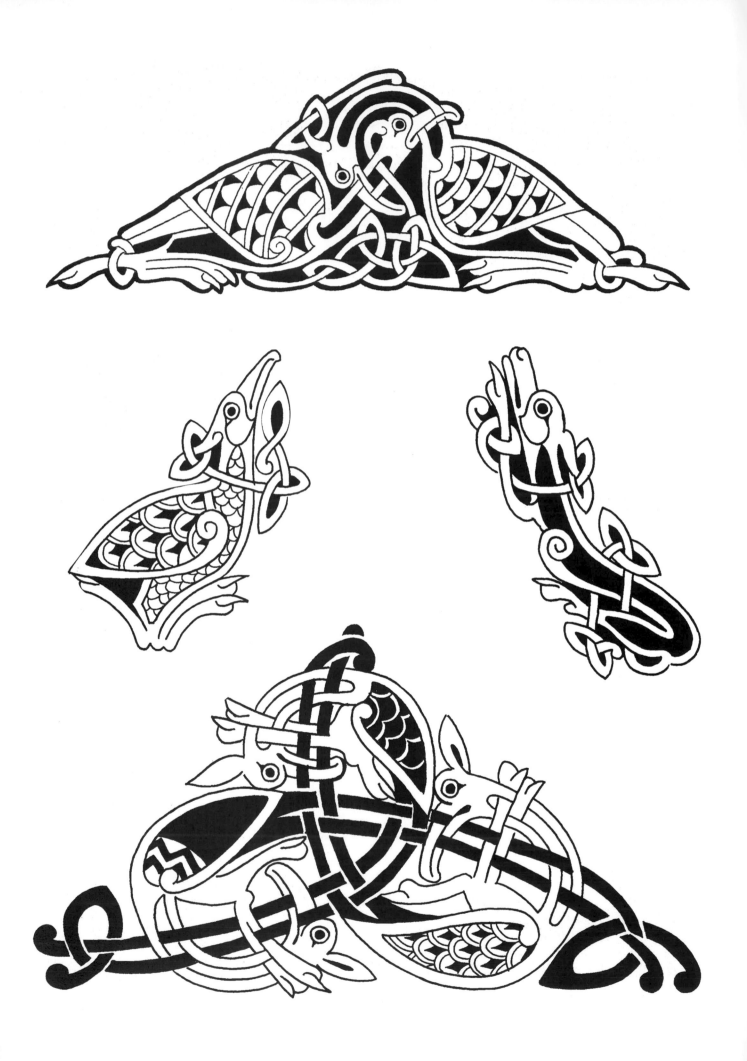

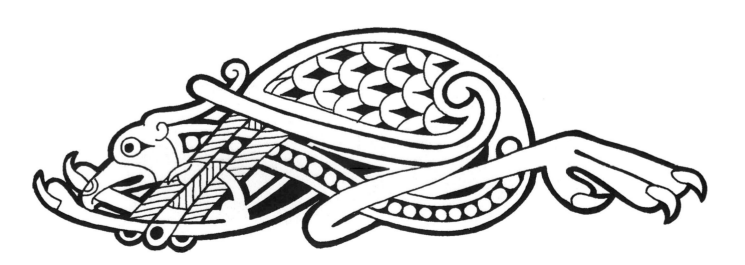

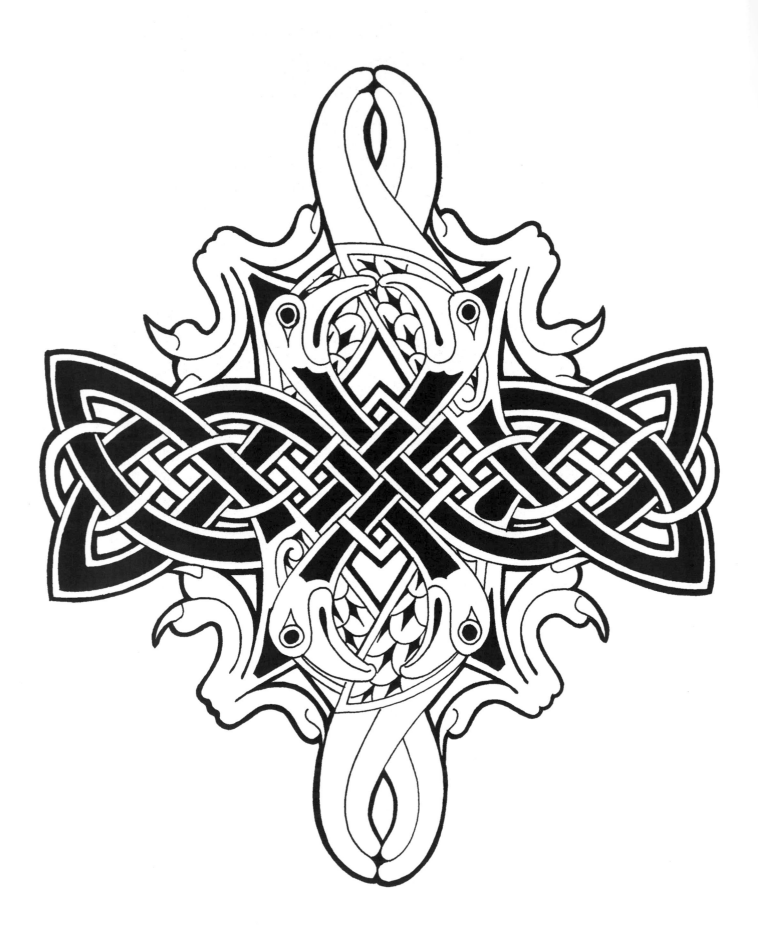

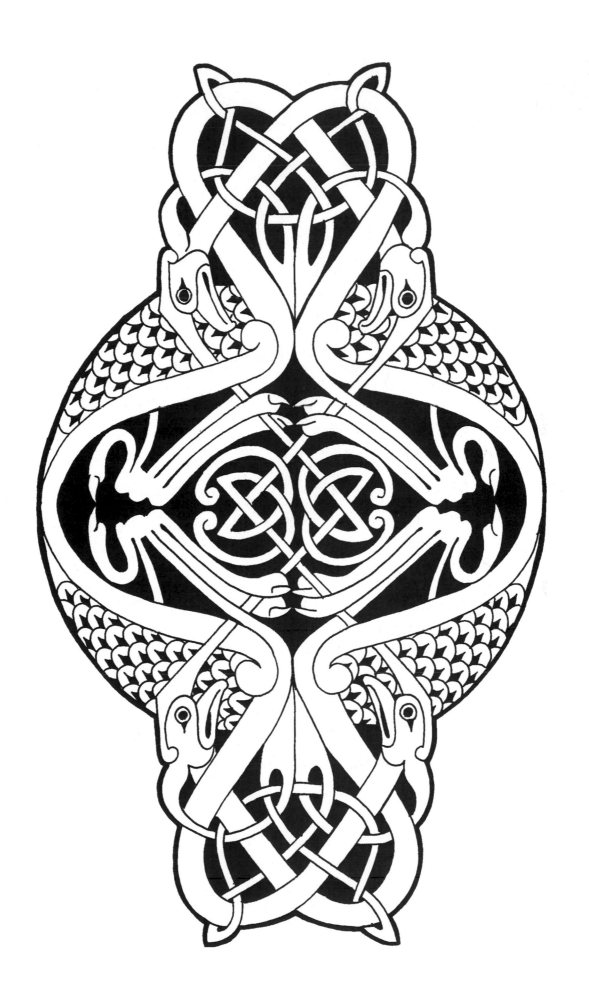

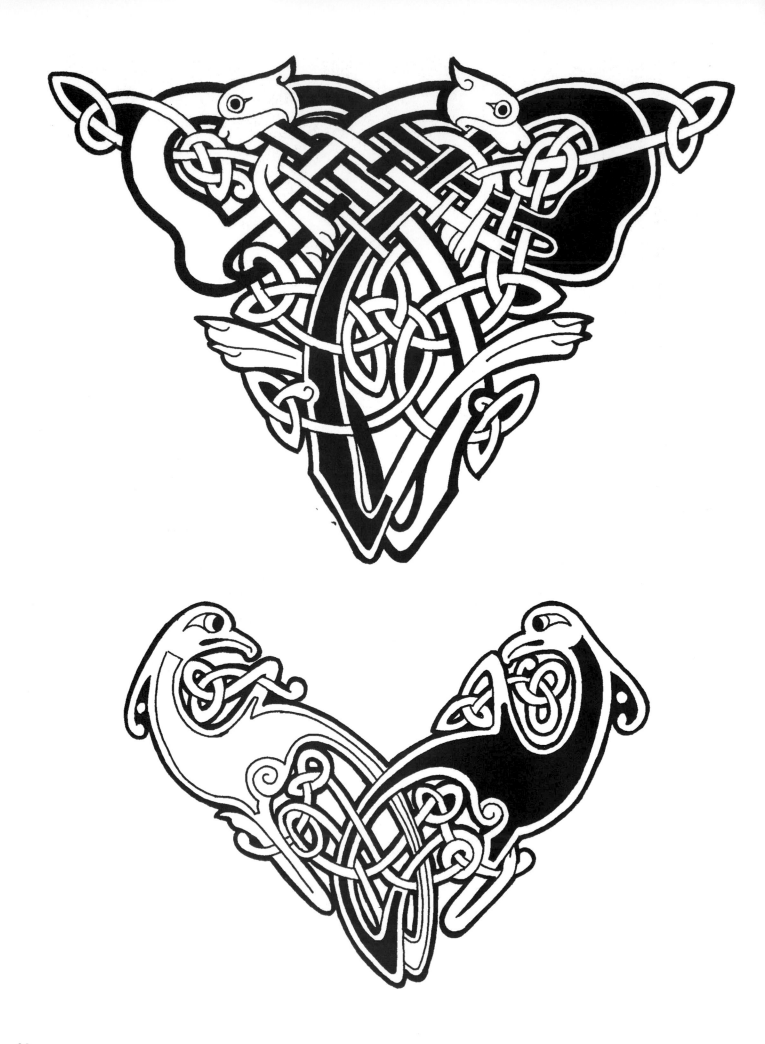

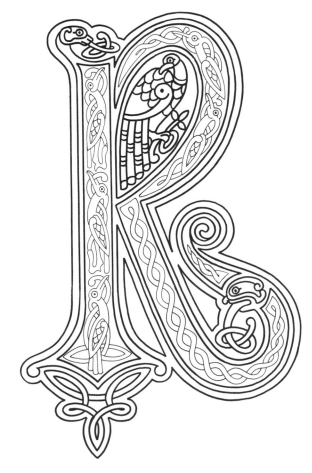

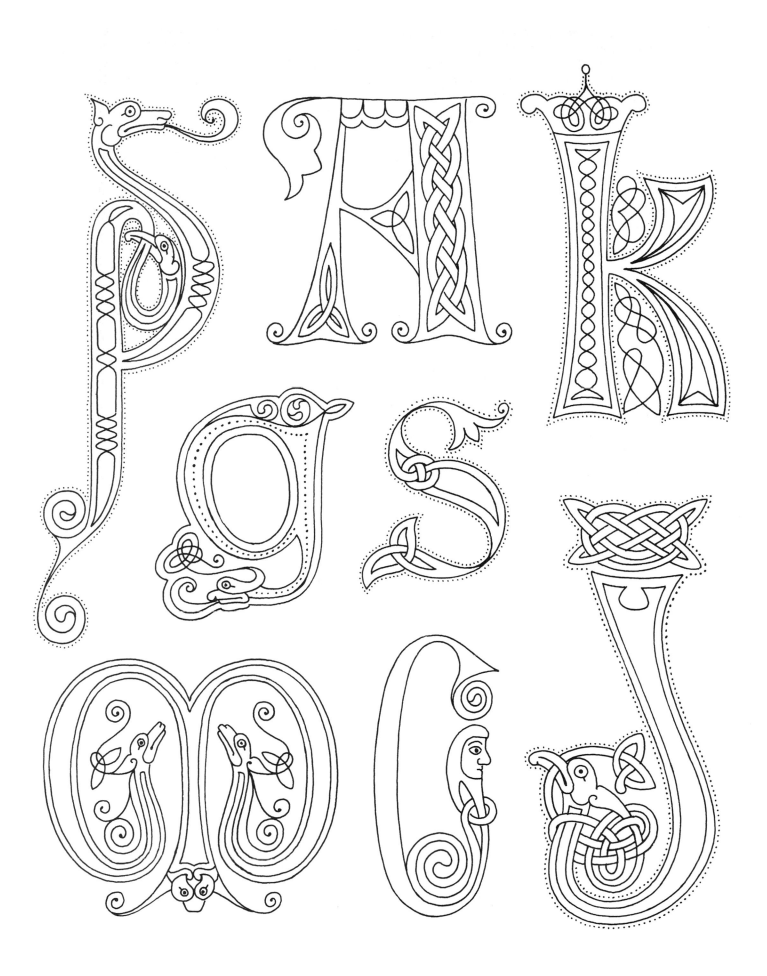

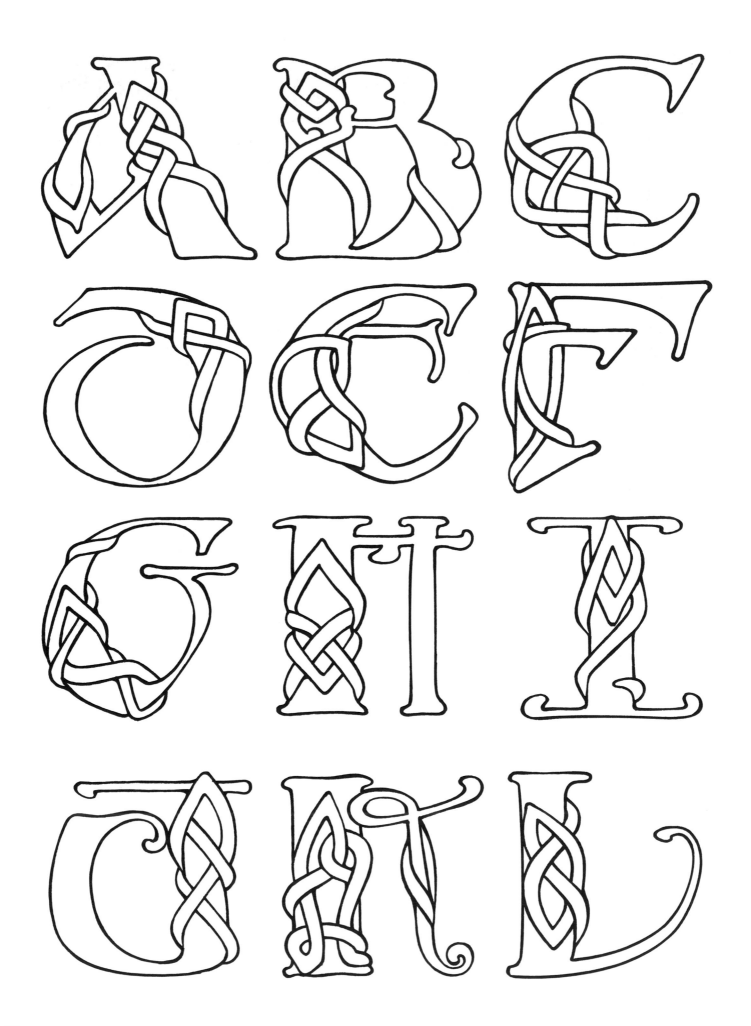

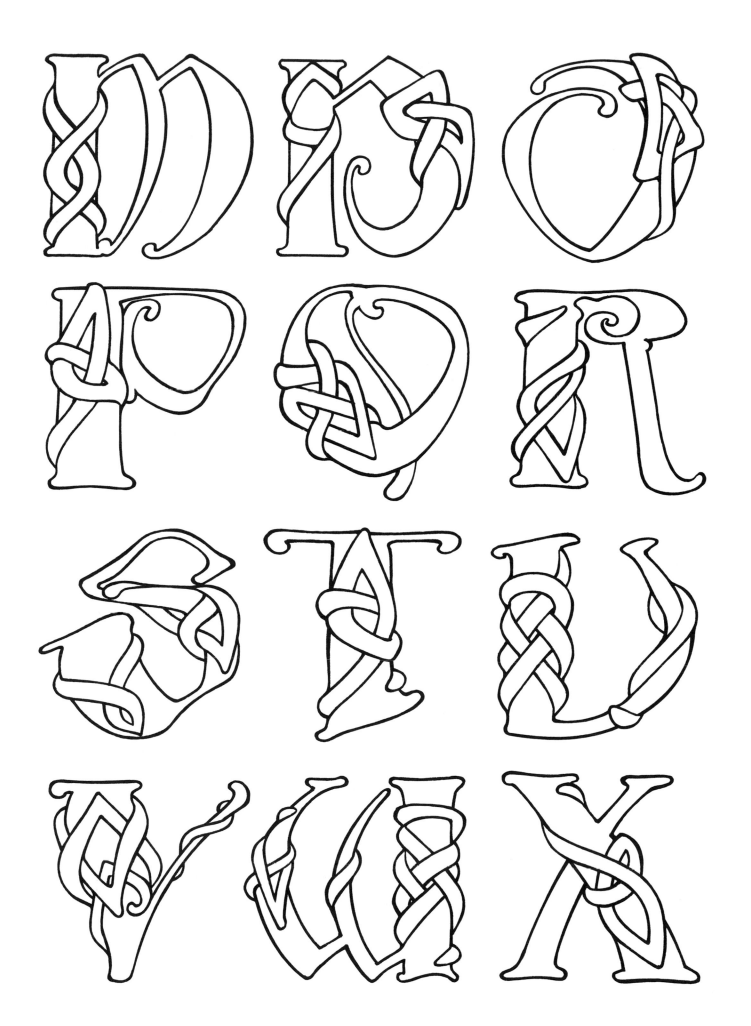

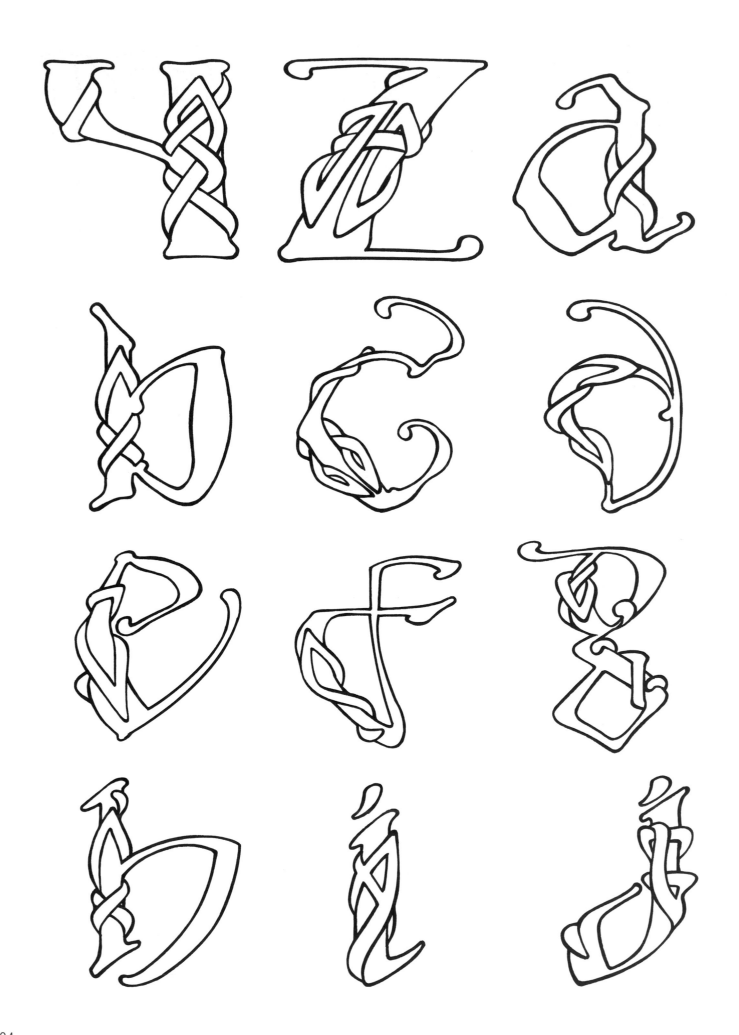

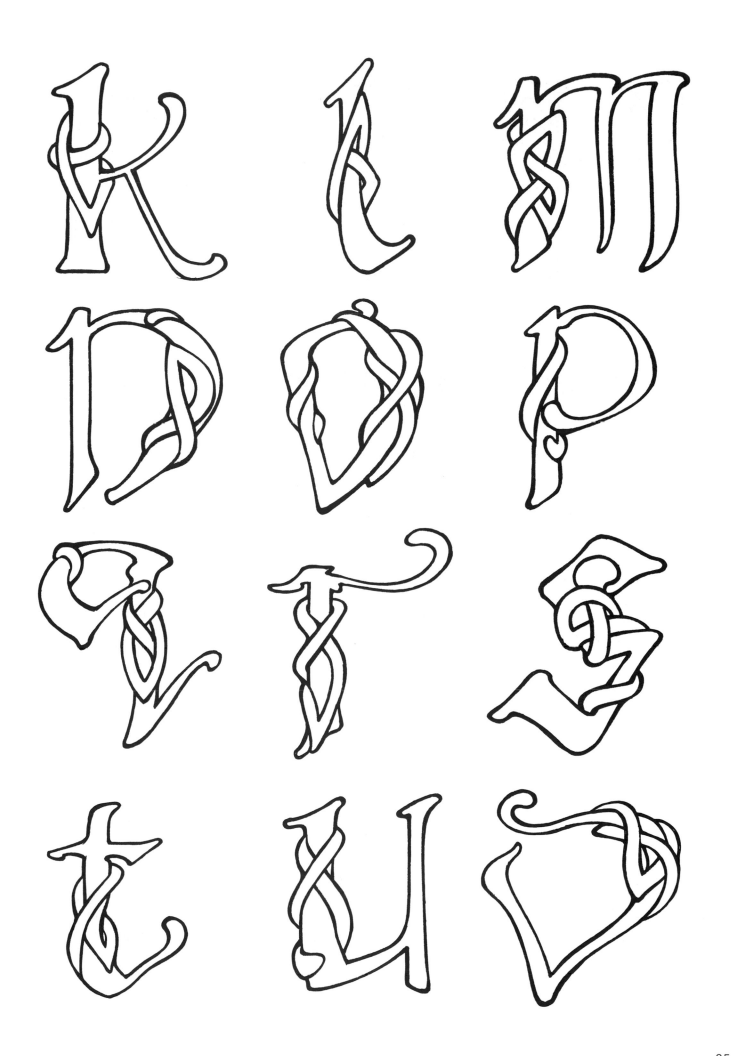

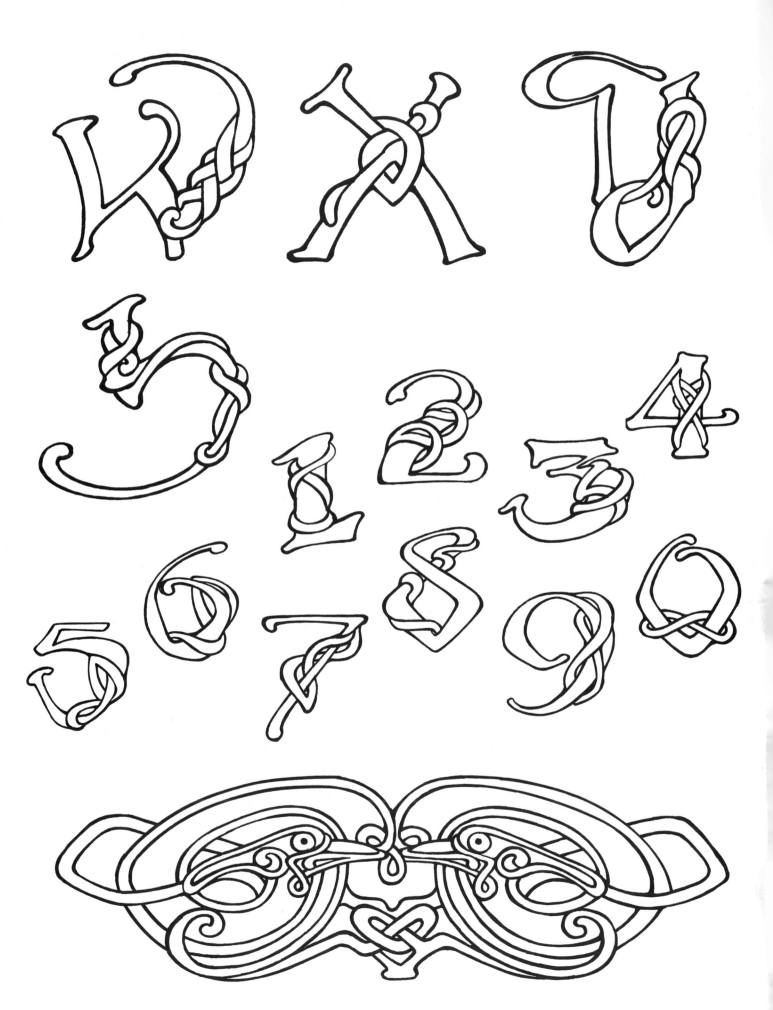